The Painterly Approach

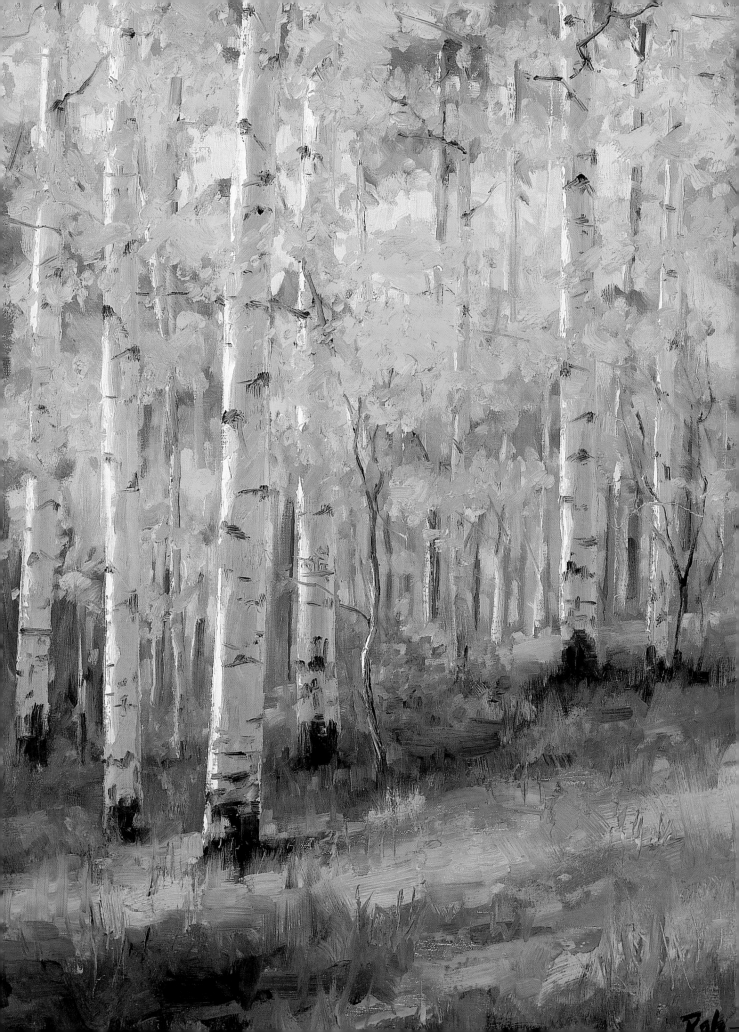

The Painterly Approach

An Artist's Guide to Seeing, Painting and Expressing

Bob Rohm

NORTH LIGHT BOOKS
CINCINNATI, OHIO
www.artistsnetwork.com

The Painterly Approach: An Artist's Guide to Seeing, Painting and Expressing. Copyright © 2008 by Bob Rohm. Printed in USA. All rights reserved. No part of this book may be reproduced in any form or by any electronic or mechanical means including information storage and retrieval systems without permission in writing from the publisher, except by a reviewer who may quote brief passages in a review. Published by North Light Books, an imprint of F+W Publications, Inc., 4700 East Galbraith Road, Cincinnati, Ohio, 45236. (800) 289-0963. First Edition.

Other fine North Light Books are available from your local bookstore, art supply store or visit our website at www.fwpublications.com.

17 16 15 14 13 8 7 6 5 4

DISTRIBUTED IN CANADA BY FRASER DIRECT
100 Armstrong Avenue
Georgetown, ON, Canada L7G 5S4
Tel: (905) 877-4411

DISTRIBUTED IN THE U.K. AND EUROPE BY
DAVID & CHARLES
Brunel House, Newton Abbot, Devon, TQ12 4PU,
England
Tel: (+44) 1626 323200, Fax: (+44) 1626 323319
E-mail: postmaster@davidandcharles.co.uk

DISTRIBUTED IN AUSTRALIA BY CAPRICORN LINK
P.O. Box 704, S. Windsor NSW, 2756 Australia
Tel: (02) 4577-3555

Library of Congress Cataloging in Publication Data
Rohm, Bob.
 The painterly approach : an artist's guide to seeing,
painting and
expressing / by Bob Rohm.
 p. cm.
 Includes index.
 ISBN 978-1-58180-998-5 (hardcover : alk. paper)
 1. Painting--Technique. I. Title.
 ND1500.R58 2008
 751--dc22
 2008005538

EDITOR: Kelly C. Messerly
DESIGNER: Brian Roeth
PRODUCTION COORDINATOR: Matt Wagner

F+W PUBLICATIONS, INC.

About the Author

Bob was born and raised in central Pennsylvania and has been painting for most of his life. He received formal art training at the York Academy of Arts in Pennsylvania. After graduating, he painted part time as he followed a career in film and video production that eventually led him to reside in Texas. He has been painting full time since the early 1990s.

Bob juries shows, teaches workshops, lectures and demonstrates in oil and pastel mediums. Known for his expressive brushwork and an ability to capture the poetry of light, he has received many awards and is a signature member of several art organizations, including the Pastel Society of America and Oil Painters of America. He has been featured in several books and periodicals, including *Southwest Art*, *American Artist*, *The Artist's Magazine*, *The Pastel Journal*, *International Artist* and *Pure Color*, published by North Light Books.

METRIC CONVERSION CHART

To convert	to	multiply by
Inches	Centimeters	2.54
Centimeters	Inches	0.4
Feet	Centimeters	30.5
Centimeters	Feet	0.03
Yards	Meters	0.9
Meters	Yards	1.1

ART ON COVER
TRANQUIL ILLUMINATION
Oil on linen panel
18" × 24" (46cm × 61cm)

ART ON PAGE 2
YELLOW TREES
Oil on linen panel
24" × 18" (61cm × 46cm)

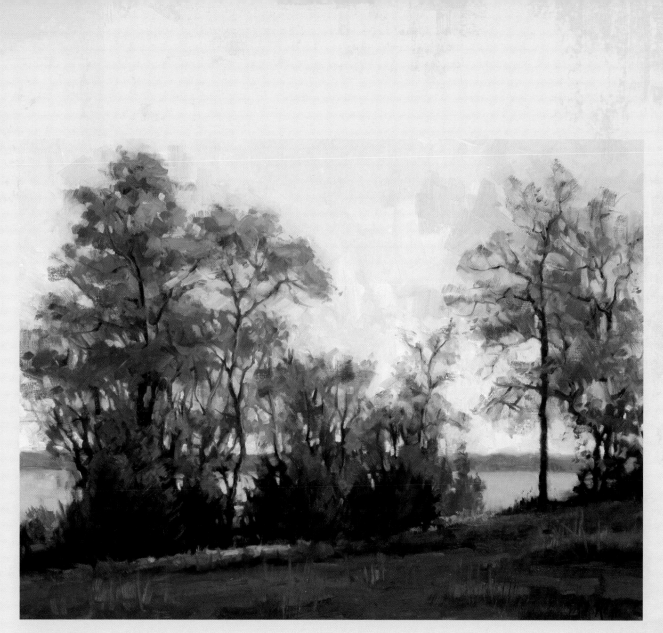

LAKESIDE COLOR
Oil on linen panel, 18" × 24" (46cm × 61cm)

Acknowledgments

I would like to thank the many artists and teachers who so graciously shared their knowledge with me. To Albert Handell, who taught me so much and continues to inspire me; and especially to my teacher, mentor and good friend Ann Templeton. Those of us who are fortunate enough to know Ann treasure her.

I also want to thank Jamie Markle, Publisher, for his guidance and recognition of this book project; Kelly Messerly, Editor, for her help in organizing my materials and editing my rambling words; and Michael Chesley Johnson for his help developing and writing the concept for this book.

Dedication

This book is dedicated to my son David, daughter Kelly, and especially my wife Lynn, who has encouraged and supported me in my passion and pursuit of painting.

table of contents

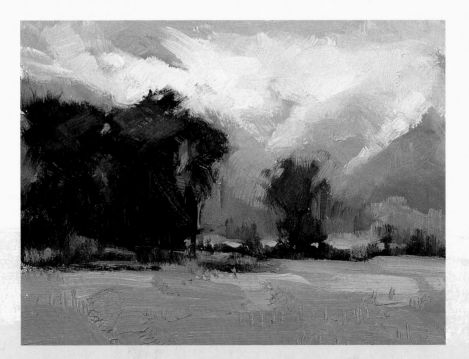

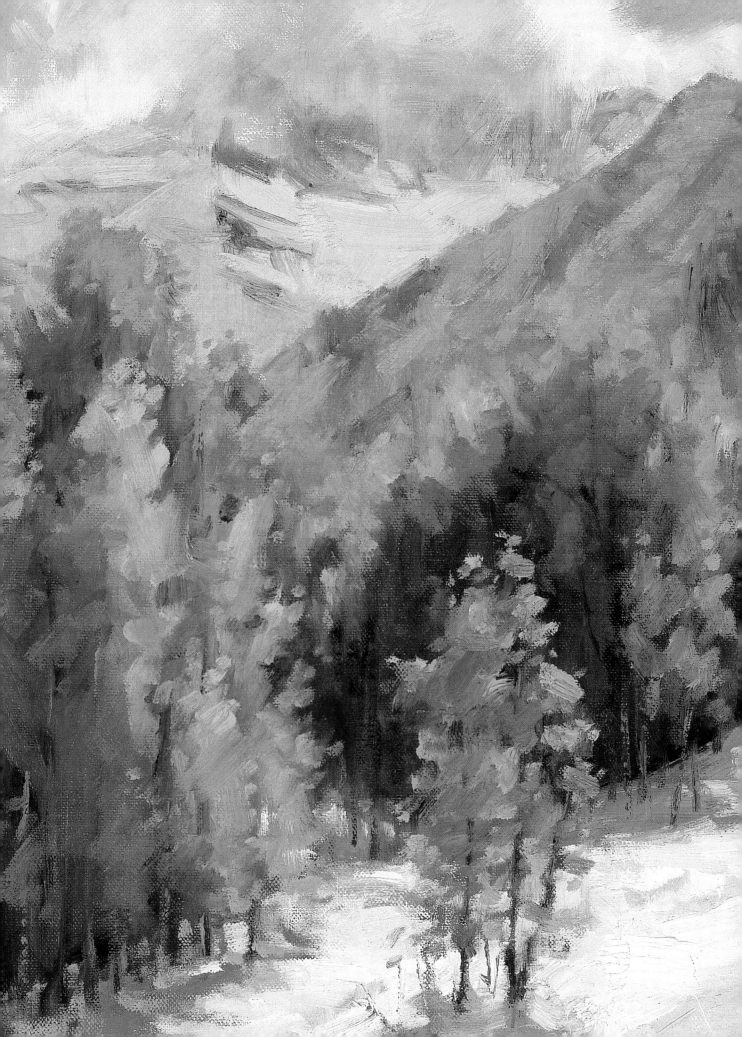

introduction

Painterly is a term that is used far too widely and often incorrectly when describing art. It seems that drawing is somehow considered a lesser form of fine art. The first thing that I want you to clearly understand is that it is not lesser in any way. It is just different. Painterly and drawing are the two basic approaches to creating art. Each is equally valid. Every approach you have ever heard about is a variation or combination of these two.

My hope is for you to understand the differences between the two and find a balanced approach for your own work. More has been written and taught regarding the drawing approach, probably because it was the way of the Old Masters

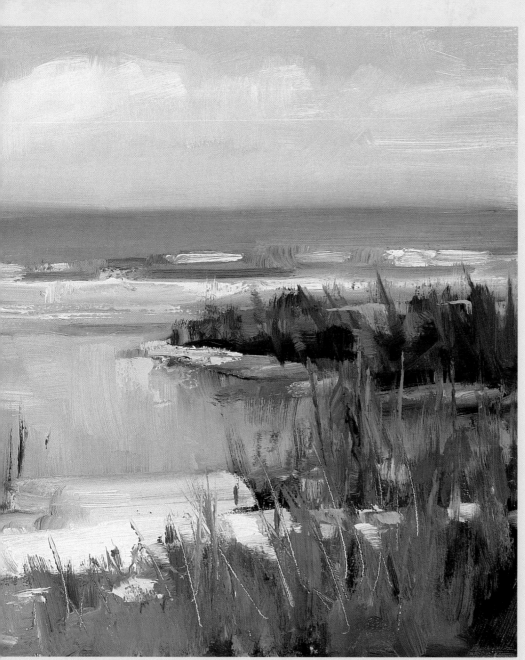

MARSH PATH
Oil on linen panel
8" × 12" (20cm × 31cm)

and it is where we start as children with crayons and coloring books, filling in accurate and unchangeable outlines instead of creating relationships of masses.

Drawing is a linear approach to creating a painting with an emphasis on the exactness of the subject contours and form. The painterly approach is a shape and mass approach. There are almost as many variations and combinations of these two as there are artists. No matter how you work, the starting point should be based in one or the other of these two concepts with a clear understanding of the difference. Then you will choose to use one or the other from a position of knowledge.

The painterliness and poetry of painting is how we use line, edges and masses to suggest and express ourselves as artists. As with literature, the poetry of painting suggests rather than fully describes the subject as in a textbook or technical manual. A work started in a linear approach can be finished in a painterly and poetic manner by loosing edges and definition, causing the viewer to become engaged in thought and in the interpretation of the subject and mood.

The painterly approach suggests form, detail and mood from the start as each part relates to the poetry of the whole.

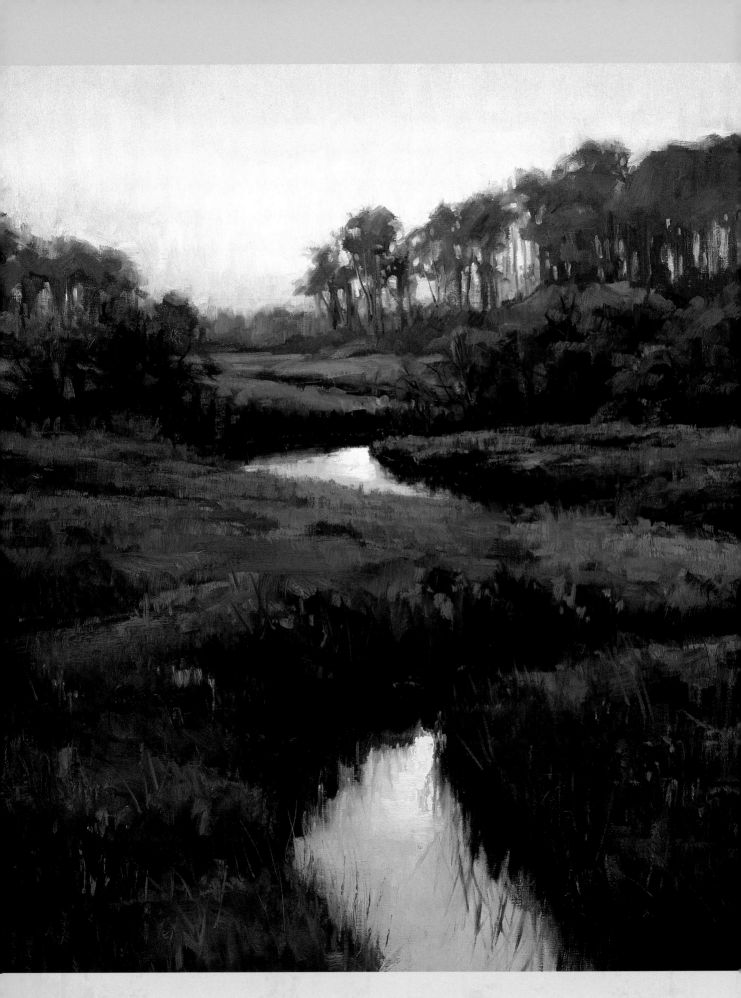

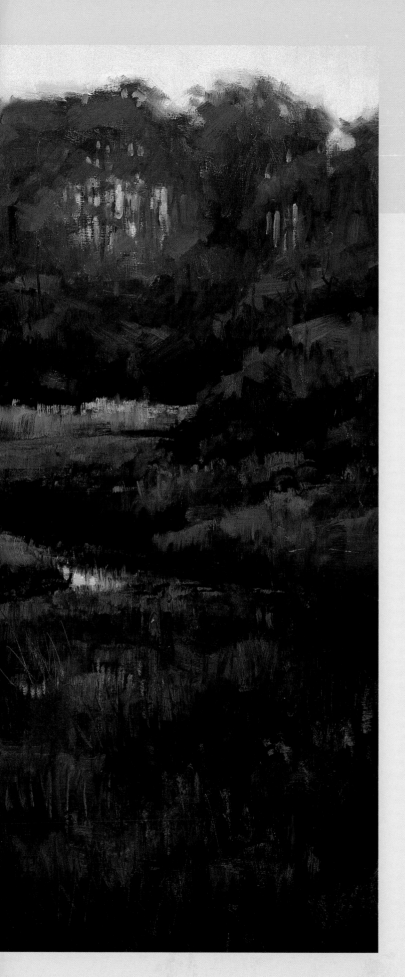

1

Materials

With the right combination of materials and equipment, you'll find it easier to get the results you want with a painterly approach. This chapter will jump-start you on the road to learning to paint in a painterly way.

EVENING WETLAND REFLECTION
Oil on linen panel
30" × 40" (76cm × 102cm)

Brushes

Consider your brush an extension of your arm and the conduit that carries the energy of painting from you to the canvas. It's the most important tool for the painterly painter. It will help you execute your ideas about paint effects and the surface. Try to find the brush that gives you the look you want and the effects you like, and then stick with it.

Brushes come in many different shapes, but I mainly use flats, brights and filberts. A flat has a square end. The bright looks like a flat, but the bristles are shorter. A filbert has a rounded end.

Use flats for landscapes, and flats and filberts for figure painting. You can layer the paint and work wet-into-wet with a flat. The bright tends to dig into lower layers of paint and disturb them. Brights are fine for underpainting and laying down the first layer. After that you'll need the more flexible flat.

When used for figure work, however, the flat's rectangular shape creates pronounced angular edges, which look out of place on the figure's soft contours. Here, the filbert is best since its long, flexible yet rounded tip produces a less obvious edge. The flat's angular edges are appropriate for a rugged figure, but if you're trying to capture a soft or romantic mood, the filbert is a better choice.

Brushes for Inside or Outside Work

Use the same natural bristle brush set while working indoors or outdoors. For painting outdoors, carry only the brushes you need: four no. 6 flats, two no. 8 or 10 flats and one no. 12 flat. Also carry a no. 2 round or an extra long filbert. These are great for creating tree limbs and small, clean marks of color.

Use a small, soft sable liner for signing your name. It's a good idea to keep a supply of new brushes on hand. You never know when you'll need that clean, chiseled stroke that you just can't get with a worn brush.

Acrylic Brushes

You need to use different brushes with acrylic. For laying in masses, use mostly large, inexpensive 1-inch (25mm) to 2-inch (51mm) bristle brushes, including small house-painting brushes. For more controlled painting, use a variety of nylon flats in sizes from no. 6 to no. 12. The natural bristles of good oil brushes can't handle the water used to thin acrylic. They will swell and lose their shape. Plus, the way you scrub in layers of acrylics would ruin a good bristle brush in no time.

SAVE YOUR WORN FLATS

If you use brights, there's little need to buy them. Brushes wear down quickly, and flats become brights in no time. Since I prefer the longer flat, I have stacks of half-worn ones that look similar to brand-new brights.

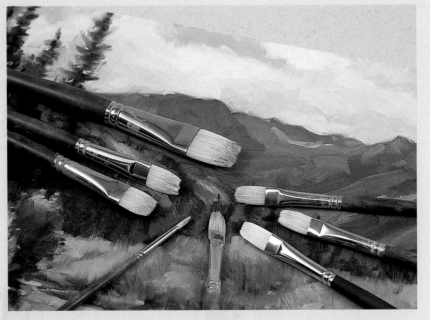

Brushes

My brush of choice is the bristle flat. Mostly, I use the no. 6, but I also carry two no. 8 or 10 flats plus a no. 12 for underpainting. New flats can carry a lot of paint and lay it on top of other layers of wet paint; worn flats and brights tend to dig into a wet surface. I also like the chiseled look the squared flat gives compared to the curve of a filbert. That curved shape is well suited to figure painting, so for that I use bristle filberts in sizes no. 4 through no. 10.

I like new brushes, but I've seen many excellent professionals work exclusively with old, worn-out ones. This proves that there is no magic brush. It's a matter of finding which tool helps you achieve your goal.

Painting Knives

The painting knife is also a valuable tool for painterly painting. You can paint very effectively with just knives and no brushes. But, if you do use both, be careful you don't overuse the knife. It creates a distinctive look, and a small amount goes a long way. Don't give both the brush and knife equal time on the canvas. Either the brush or the knife must dominate.

The knife has an advantage over the brush in that it can lay down clean color regardless of how much paint is on the surface. Clean color can be difficult with a brush—even the flexible flat can dig down and get muddy into the lower layers. The knife can slide right across the very top layer of paint.

It's a good idea to have at least two painting knives in your paint kit and in the studio. Try a large, 3-inch (75mm) painting knife and a smaller 1-inch (25mm) knife. A palette knife is blunt and stiff, while a painting knife is flexible with a good spring to it. You can use a palette knife to scrape your palette, mix paint and scrape out the occasional painting that goes awry. However, I prefer to use a large, 3-inch (75mm) painting knife for these purposes instead. It's also useful for quieting a field of grasses, the leaves of a tree or any area that's become too busy with color or texture.

Since the 1-inch (25mm) painting knife is smaller, it's more precise. Spend more money for this small knife to get good quality, and use it only at particular times when the quality of the stroke is important. Use this knife to make small lines and accents and to emphasize the most dynamic edges. By the way, a

small painting knife is delicate. If it ever gets bent, throw it away. No matter how you try to straighten it, it'll never be right and never give you the control to make a clean, straight edge. It's cheaper to buy a new one than to struggle with a bent one.

When working with acrylics, use large, inexpensive plastic knives for mixing but a good metal knife for painting. There's no difference between using knives in oil and using them in acrylics for their effectiveness in the painting.

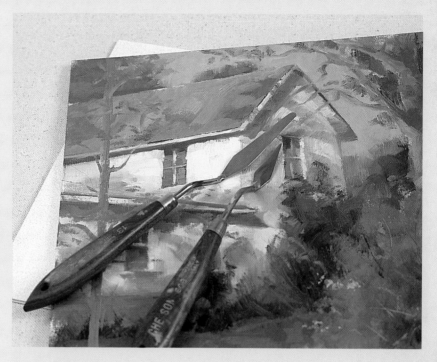

Painting Knives
Always carry two painting knives. Use the larger one to mix color and clean your palette. You can occasionally use it to make a large mark, quiet a busy area of grasses, scrape down a weak area or scrape away an entire painting.

The smaller knife, about 1-inch (25mm) long and narrow, should be used strictly for painting. Notice the sharp, clear edge that was placed on the roof in the painting with this knife. Use it for dynamic accents, but don't get carried away or it will no longer be an accent.

PAINTING EDGES WITH A KNIFE
You can only make one good edge at a time, so don't fight it.
Make the good edge where you need it, then go back and modify the other edges later.

Paints

Oil Paints

When selecting your paints, choose a consistency that best suits how you work. Some brands are firm while others are creamy and smooth and perfect for painterly effects. Some are too soft and don't layer well. Painters have individual preferences, but generally, those working in similar styles tend to choose the same brands. My brands may not be to your liking, so try several brands under different conditions to decide what is best for your style.

One thing to consider is the pigment-to-filler ratio in paints. Many student-grade brands use high-quality pigments, but they're so loaded with fillers that their tinting strength is weakened and you need a lot of each hue to get the mixture you want. A more expensive, artist-grade brand has more pure pigment—and thus a higher price—but it lets you get the mixtures you want with less effort and less paint. A good-quality, highly-pigmented paint for which you pay more per tube will go further than a tube of the student-grade brand.

One side effect of using quality, artist-grade paints is that you will use more white and less pigment because of the greater tinting strength of these paints. White is the least expensive paint on your palette, so, by purchasing quality paints, you'll likely spend the same amount overall—or maybe even a little less—than by buying cheaper paints.

Besides price and quality, you need to think about chemistry. The colors of Holbein, Gamblin and Rembrandt stay consistent within the range of colors throughout. I know what to expect when working with them at any temperature or environmental condition.

Here are some things to look for when you're buying colors:

- Try many brands to find the tinting strength that works best for you.
- Get brands of a consistency that suits your style.
- Get good-quality pigment that won't migrate into other colors or fade over time.
- Get paints that respond to heat and cold in the same way (for example, one that doesn't get stiff while the others remain smooth).
- Get the best paint for your needs at a price you can afford.
- Don't be afraid to use a lot of paint. It's far better to throw some away than to try to paint without enough on your palette or brush.

Here's a tip for that last item: Buy expensive pigments in moderately priced brands and the less-expensive pigments in the more-expensive brands. For example, use Rembrandt Cadmium Yellow (expensive pigment, moderately priced brand) and Holbein Ultramarine Blue (less-expensive pigment, more-expensive brand).

Try to get used to laying out your colors the same way each time you paint and organize them in the logical order of the color wheel. Start with the warmest and lightest

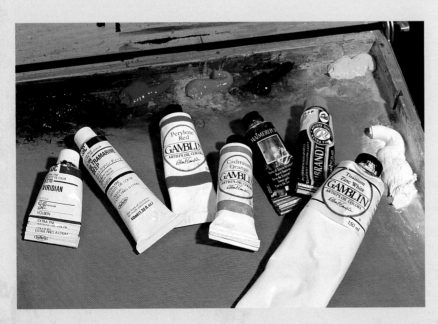

Oil Color Palette

My basic oil color palette consists of these paints:

- Cadmium Yellow Light
- Cadmium Orange or Mono Orange
- Burnt Sienna
- Perylene Red or Alizarin Permanent
- Ultramarine Blue
- Viridian
- Titanium-Zinc White

I sometimes use more or fewer colors, different hues and different brands. I'll use and discuss many different hues and combinations in this book, but this is my most commonly used oil palette for both studio and on location.

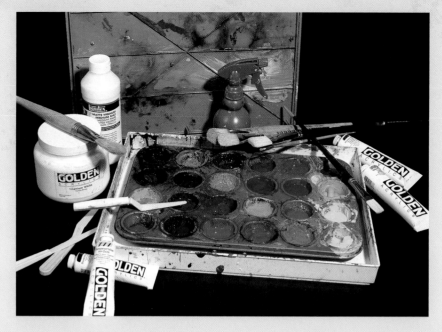

Acrylic Color Palette

My acrylic palette is a small muffin tin stored in an airtight plastic palette seal. I spray the palette with water and seal it after each painting session to keep the colors moist. Eventually the muffin tin will rust through on the bottom and I will simply replace it. The colors stay fresh and last a long time. Since I work these colors fairly transparent, the water accumulation from spraying is not an issue. Dab the excess with a paper towel as needed.

values on the right, move through the reds to the coolest and darkest blues. If you laid these colors in a circle they would form a color wheel. With this layout, you can add new colors by placing them where they fall on the color wheel.

As you take color the brush is pointed into the color pool. I'm left-handed so the white is at right. If you are right-handed, start with the white and yellow on the left.

By laying your colors out the same way each time, you get used to their placement and it becomes second nature to select each hue. One less thing to think about while you are painting is a very good thing.

Acrylic Paints

As with oil paints, artist-grade acrylics have a better ratio of pigment to filler. The student-grade brands tend to have a thinner consistency with less tinting strength. In addition, the lightfastness of student-grade paints can be an issue. If you sell your work, you owe it to your clients to use quality materials.

My acrylic color palette has expanded quite a bit from my oil one. I find it harder to mix a wide variety of clean colors with acrylic. Many hues tend to gray out when mixed. The colors you can mix are great, but the range is limited. I've found that working with an expanded palette gives me a better range of clean hues. When it comes to acrylics, I'm just not satisfied with less!

Handle acrylic differently from oil. Thin acrylics to create soft edges with transparency and dry-brush effects to build colors in layers. With oils the colors are more direct and less layered. Acrylics can look very opaque if you're not careful. For a thinning agent, use three parts Liquitex fluid Matte Medium mixed with one part distilled water.

My palette includes the following Golden Heavy Body Acrylic paints:
- Cadmium Yellow Light
- Yellow Ochre
- Cadmium Yellow Medium
- Cadmium Orange
- Burnt Sienna
- Quinacridone Red Light
- Quinacridone Red
- Quinacridone Crimson
- Ultramarine Violet
- Cobalt Blue
- Chromium Oxide Green
- Permanent Green Light
- Titanium White

I often add others that appeal to me at the time, but this is the palette I always start with.

DEVELOP A STANDARD PALETTE

I keep the basic palette pretty standard, but I love to experiment with various brands and pigments. You should find the brand and pigments that are right for your style before you start experimenting with others, however. These standard pigments will give you a benchmark you can compare everything to.

Pastels

Pastels are often used as a drawing medium, but they can also be used to achieve a painterly style. Using the linear approach with pastel and allowing a lot of the paper color to dominate the work is typical of drawing. Handling pastels like oils, such as modifying masses of layered color to produce a surface quality of thick and thin shapes, is painting. The beauty of pastel painting is that it combines the best qualities of drawing and painting in a painterly manner.

Keep in mind that painting versus drawing is an approach to constructing the work of art, not the result of whether the medium is wet or dry.

Think of pastels as having three degrees of softness and hardness. At one end sits the thin sticks of hard pastels such as NuPastel and Cretacolor brands. These lay down the least amount of pigment, make thin lines and fill areas where you don't want a lot of pigment built up.

In the middle are many brands of different sizes, including Rembrandt, Winsor & Newton, Mount Vision, Daler-Rowney, Holbein, Art Spectrum, Girault and, on the softer side of this middle range, Unison. Some are harder than others, but there's a big range between the hardest and softest brands. Consider this middle range as the workhorse of the pastel sets. With them, you can deposit a fair amount of pigment, but they're still firm enough to create thin, crisp marks and layer color without clogging the tooth of the surface.

At the softest end sit Sennelier, Great American Art Works, Schmincke, Diane Townsend and Terry Ludwig, to name a few. These

Pastels for Location Work
On location I carry two boxes of pastels. The smaller box contains a full set of hard pastels and a selection of pastel and charcoal pencils. The larger folding box has my palette of medium and soft pastels. All are half sticks or smaller, without wrappers. This is the best way to pack the largest variety of color, value and grade. They are arranged from right to left, with yellows, reds, violets, blues, greens and dull neutral hues. This is the same basic layout as my oil palette. Consistency is important.

luscious, soft pastels are buttery and deposit a lot of pigment with each stroke. They're great for solid areas of color, final statements and accents.

Pastels for Studio Work

Organize your colors by primary and secondary colors, light, warm and cool tints, and, finally, neutral colors. Store them in plastic trays for each. Keep hard pastels separate from the others, but combine the medium and soft ones. By making a small test mark, you can quickly determine a stick's degree of softness, and after time you will make this determination simply by touch.

Pastels for Outdoor Work

After years of trial and error, I've reached a set that works well for me in the field, with an "on-location" box containing a mix of about two hundred medium and soft pastels. The softest pastels are light value colors, used in big areas such as the sky and for brilliant accents. The middle range includes values and colors that work well for building the forms and masses of a landscape. Because of the great variety of greens found in landscapes, this middle range also has a great variety of greens—in fact, more variety than any other color. Carry a small box with a complete set of hard pastels, which you can use for dark areas, accents and underpainting.

Painting Surfaces

Oil and Acrylic Surfaces

For oil painting, use an oil-primed linen with a medium texture, specifically Claessens #66. For acrylics, watercolor paper and acrylic-primed cotton or linen canvas are suitable. You can be far less critical about surfaces for acrylic than those for oil and pastel. Acrylics are flexible and, when properly varnished, very durable on a variety of supports.

I prefer my oil-primed linen to be mounted on board rather than on stretcher bars. The painting will last longer because it won't expand and contract with changes in humidity or temperature. Flexing will crack a dry, brittle oil painting. Also, I live at a low elevation, but many of my galleries are located above 5,000 feet (1,524m) in Santa Fe, New Mexico, and Aspen, Colorado. When a stretched canvas goes from a lower altitude to a higher one, it expands and loses its tautness. Not only does it look bad, but flexing can damage the surface. Many times in the past, galleries were forced to re-stretch works, which I had to pay for, of course.

Boards are also thinner than stretched canvas, and thus more compact. Also, the panels don't transmit light. Stretched canvas lets light pass through like a window curtain. If you have ever tried to paint outdoors on a stretched canvas with the sun beaming through it from behind, you know what I'm talking about. That light makes it very difficult to see the colors and values correctly.

You can have large studio panels custom-made using the same birch plywood as the on-location panels; just make sure they have wood strips added to the back for support.

One of these panels weighs about the same as a stretched canvas, but will not expand and loosen like one that is stretched.

Pastel Surfaces

For pastels, use a sanded paper that holds layers of color without the need for fixative. My preferred surface for pastel painting is Wallis Sanded Pastel Paper mounted on museum board. Try sanded pastel paper dry-mounted on museum board or Gator board. Trim the mounted boards to the right size so they will fit in the same wet panel boxes as your oil paintings, making travel with both a cinch. There are so many quality papers available today that you don't need to make your own, unless you want to experiment.

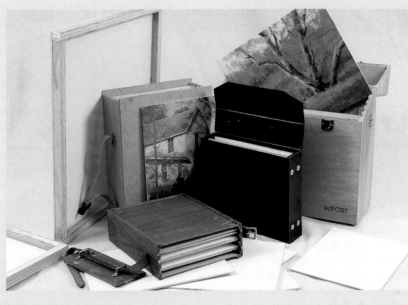

Painting Surfaces

Here are several panel boxes from a number of different manufacturers, from fine quality wood to plastic and plywood with movable slots to accommodate various sized panels. Many easel and panel makers now offer them as part of their product lines. Consider carefully the sizes you work with outdoors, if you are traveling by car or by air, and how many wet paintings you need to carry. When traveling by car, I carry several sizes plus small boxes for my painting kit. When traveling by air, I limit my panels to one size and have one small two-slot box for the paint kit, plus a box with more slots kept in my suitcase.

Solvents, Mediums and Varnishes

Solvents

Gamsol by Gamblin is a safe solvent to use to thin mixtures and rinse oil painting brushes. I also use Turpenoid Natural to clean and condition my brushes at the end of the day. If my brushes will sit for more than two days, I wash them with soap and water. Otherwise I just rinse them with Turpenoid Natural at the end of each painting session.

Mediums

There are many fine painting mediums on the market. Some are designed to work like the traditional mixture of one part stand oil, one part damar varnish and four parts turpentine or mineral spirits. This is a good medium, but, truth be told, I use medium very seldom these days. I once used it for thinning mixtures and for glazing, but after I settled on a palette of colors with a smooth consistency, I found I don't need a medium.

In the early stages of a painting, you may find it helpful to use a small amount of mineral spirits to thin the paint so you can cover the surface more easily. Don't make your paint too watery, though. You're better off scrubbing the paint into the surface with very little solvent or medium when working wet-into-wet than taking a slopping wet brush to it. A drier application makes it much easier to add wet layers of paint.

It is a good idea to use a medium when you travel. A touch of a quick-drying medium, like Winsor & Newton's Liquin or Gamblin's Galkyd Lite, dabbed into each paint mixture speeds up the drying process. This makes it easier to pack and transport paintings. But easy does it—these mediums set up very fast in warm, dry climates, and your paint surface may become tacky before you finish working. Nothing is more frustrating than a sticky paint surface.

Mediums are useful in the studio for glazing. When reviewing work, you may find an area that's too intense or that doesn't recede into the distance enough. Just work a little Liquin or Galkyd Lite into the dry surface with a large, firm brush. Not only does it wet the surface, making it glisten like fresh paint, but it provides a binder if you apply a glaze to change an area's hue or value.

Varnishes and Fixatives

In oil painting, varnish is used to restore the intensity of colors after they've dried, and to provide a removable layer to protect the paint surface. Over time, an exposed paint surface may discolor and accumulate dust and dirt from the environment. An isolation layer of varnish allows these contaminants to be removed with the correct solvent and care.

An oil painting dries by oxidation. The paint starts to cure first at the surface and then back to the ground. The thicker the paint, the longer it takes for the air to cure it properly. Varnish is designed to seal a painting to protect it from the air, so if it's used too soon, the paint won't properly cure and may wrinkle or crack.

One school of thought says that if you spray varnish on a painting while it's still wet, the varnish becomes part of the paint, and this is OK. Well, it's not OK. Yes, the varnish becomes part of the paint surface, but it still seals the surface and prevents proper curing.

Retouch varnish is a temporary varnish. Like regular varnish, it also restores the brilliance of the colors. However, it's thinned so it creates a permeable layer that allows paint to continue to cure. But if you lay it on too thickly, it's no different from a coat of regular varnish, and the paint won't cure properly. Apply retouch varnish thinly to a fresh painting, and again, don't overdo it.

For large paintings, such as 24" × 30" (61cm × 76cm), brush on retouch varnish rather than apply it from a spray can. Careful brushing produces a more consistent and even coating. On small works, though, the spray can works fine.

Timing is important when varnishing. Follow these steps to varnish your painting properly:

- When the painting is dry to the touch and sometime during the first six months, brush on a retouching varnish.
- After six months, when the painting is fully cured, apply a conserving gloss varnish, also with a brush. Be sure to use a gloss finish varnish that contains UV filters as well.
- For acrylic paintings, wait two weeks for the paint to cure properly and all the moisture to evaporate. Then apply a layer of soft gel gloss as an isolation layer, let it dry overnight and then apply the varnish.

I prefer to varnish my acrylics with Golden Varnish with UVLS (ultraviolet light stabilizers). You can use either a mineral spirit-based version or a water-based one. (I use

the mineral spirit version because it produces a tougher surface.) The varnish is available in Gloss, Satin or Matte and provides UV light filtering without discoloration.

Pastels are a different matter. I do not recommend using any fixative. If you feel you must use it, there are a few acrylic forms on the market that seem to have very little effect on the colors or surface, but that do help bind the pastel particles together. The one time you might need fixative is to darken an area before applying more layers of pastel, and it's a good idea to keep a can of traditional workable fixative around the studio just for this purpose.

PASTELS AND FIXATIVES
If you use pastels of the right hardness or softness to achieve the effect you want on a surface with adequate tooth, there's no need for any fixative. What you put down will stay where you want it, and it will look the way you want it to look.

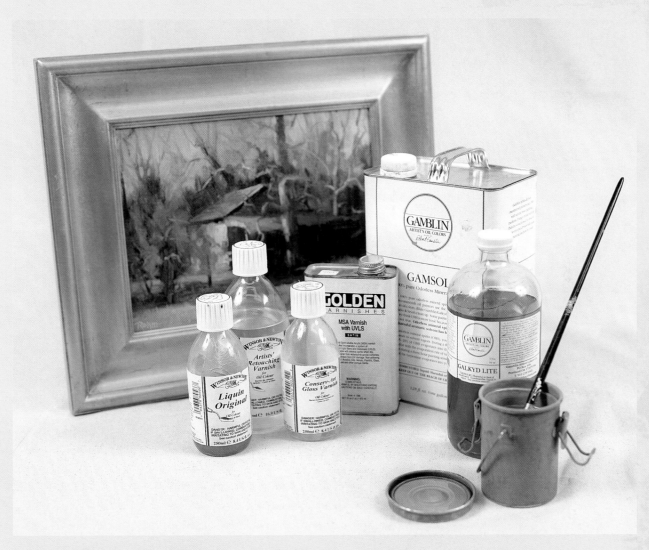

A Selection of Mediums and Varnishes
In the studio I use only Gamsol by Gamblin. Fast-dry mediums like Liquin and Galkyd Lite work well for traveling (to help dry paintings quickly) and for studio glazes. Follow the manufacturer's recommendations for oil and acrylic varnish. On a new oil painting, use retouch varnish to allow the oil paint time to cure properly. Once it's fully cured, use a finish varnish.

Studio Setup

My studio is a converted two-car garage attached to my home. Where the garage door was I installed sliding glass doors. Whenever possible, use furniture and equipment that's on rollers so you can change the arrangement depending upon the requirements of each project.

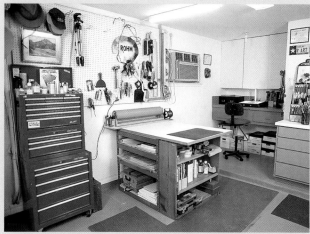

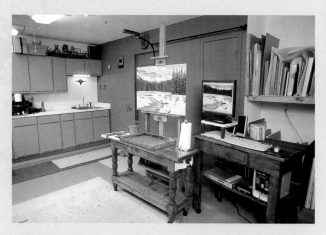

Important Work Table

Across the studio from my easel is the most valuable piece of furniture that I have—a makeshift work table. It was made by placing two adjustable shelving units back to back for large flat storage and a smaller shelf in the front for framing and packing supplies.

I use this 40" × 60" (102cm × 152cm) work surface for framing, varnishing, cutting boards, mounting canvas, packing and anything else that requires a flat work surface.

Since space is limited in my studio, it is purely functional. When I do have the occasional client visit, he seems to like visiting the workspace.

The mechanic's tool chest to the left holds all my oil and acrylic paint tubes. The space to the right rear is where I store and edit photography. Since going mostly all digital a few years ago, this space is little used anymore.

Converted Garage

You can see where I've placed my easel for the best viewing. I'm left-handed, so the window wall is to the right and will not cast a shadow of my hand onto the painting as I work. To the rear left is a sink, which is invaluable for washing brushes and working with various water media.

The wall behind my easel is painted a neutral gray. This color will not compete with the colors of my work. A white wall would distort the colors and their value relationships.

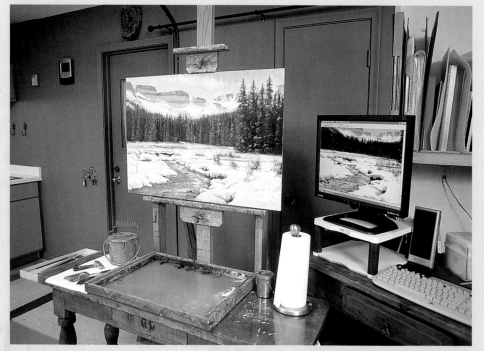

Palette Position

My palette is used under the easel rather than the side. This is a system that I have become used to working with on location and adopted to the studio. For canvases larger than 48" × 60" (122cm × 152cm), I simply roll the taboret to the side to work. Directly overhead I have a color-balanced fluorescent light fixture.

When working with photo source material, I use a computer image on a large flat-panel monitor set at a similar eye level to the canvas, much as it would be on location.

Materials for Working on Location

When working on location (*en plein air*), the most efficient setup for the way you travel and work is imperative. Focus on the painting at hand. All of your tools and equipment need to aid your process and not be a distraction. Unless you work directly from the back of your vehicle, weight and organization are your main concerns that will allow you to focus on painting.

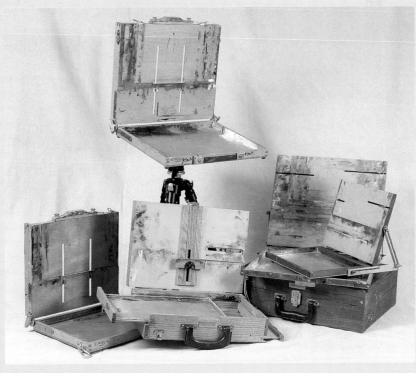

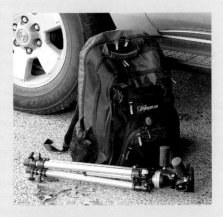

Compact Backpack

Here's everything I need to go on location for several paintings. The backpack is very compact and holds an 11" × 14" (28cm × 36cm) pochade box, 11" × 14" (28cm × 36cm) panel storage box with four panels back to back, plastic box with paints and brushes, folding pocket tool, paper towels and trash bag, solvent container, wet wipes for clean up, sunscreen and bug spray, pen and sketchbook, tripod and water bottle.

Fully loaded, the backpack weighs around 15–20 lbs. (32–42 gsm). If you want to reduce the size and weight, the best way is to paint smaller. For example, if I'm hiking any distance, the largest size I take is 8" × 10" (20cm × 25cm), and I carry a more lightweight tripod.

Pochade Boxes

For small on-location work, I prefer the pochade boxes that mount onto a camera tripod. They are compact, easy to set up and efficient. Pictured here are several brands. I like each of them for different reasons.

If you're not sure what to buy, the best advice I can give you is to borrow one and take it to a plein air painting workshop. Once there, see what others are using and evaluate the usefulness of each one, thinking about how it would fit your needs. Short of that you'll end up like me, owning practically one of every size and style made. I have many more than are pictured here.

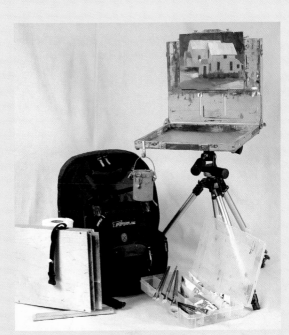

Painting Rig

This is my typical en plein air painting rig. I use a plastic fishing tackle box to store my paints, brushes, palette knives and miscellaneous clips and hooks.

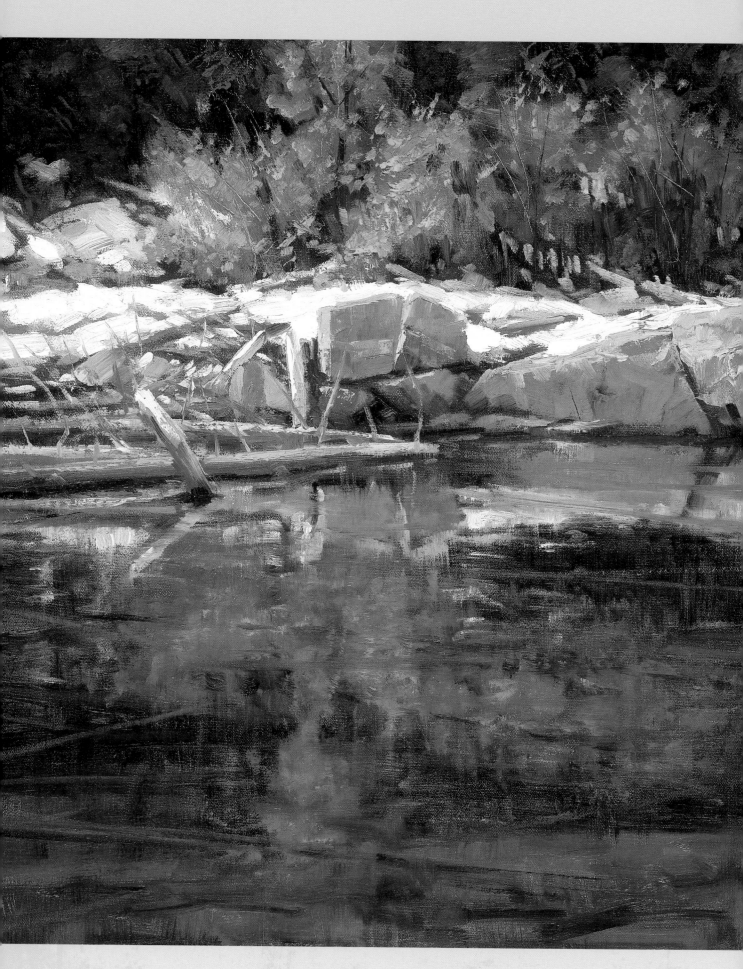

2

The Painterly Approach

Looking at the world in a painterly way is key to bringing a natural and emotional feeling to your paintings.

When I create a painting, I don't want to make an illustration of the subject. Instead, I strive to make a painting that viewers will respond to emotionally. To enable them to feel the sun, wind and tonalities I experience, I use a painterly approach.

MORNING SNOW
Oil on linen panel
18" × 24" (46cm × 61cm)

The Linear Approach

The painterly artist starts from a position of abstract relationships while the linear artist starts from one of accuracy of subject. As I said earlier, both the linear artist and the painterly artist have equally valid approaches to making their art. One is not a "finer" fine artist than the other. They just have different ways of seeing the world, different goals for their art and different ways of representing it. At one extreme we have the photorealist and at the other the abstract expressionist. Most of us fall somewhere in between. Should you take the linear approach or the painterly mass approach? You decide what suits your desire and temperament best, but you also need to be aware of the options.

The linear artist uses a line as a tool, to stress the boundaries between objects and the separation of subject, background and detail. Objects are defined with lines that outline a form or suggest the edge of a surface or plane, using accurate drawing right from the start. The objects in the linear artist's paintings look like what they are. The viewer perceives them as isolated and independent units.

The linear artist's goal is to render a likeness of objects. The value of the work lies less in its decorative potential than in how accurately it depicts the subject. To accomplish this goal, detail and how an object actually looks is stressed. Painting may seem almost mechanical; lines are filled in while trying not to disturb the accurate drawing the artist labored to establish. However, by being afraid to disturb or change an accurate start, the linear artist runs the risk of the work looking cold and mechanically produced.

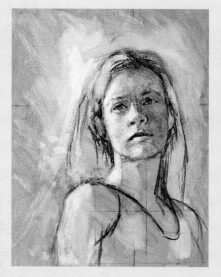

Sketch the Subject
The canvas is washed with a thin mixture of Yellow Ochre and Terra Rosa. Next, the face is drawn using charcoal and a clean rag to wipe out and erase. All features and proportions are carefully measured. The drawing is then sprayed with retouch varnish to set the charcoal.

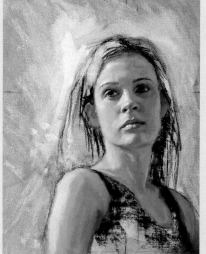

Add the Paint
Being careful to follow the drawing, features are modeled in paint with color and value. Notice how the original color wash serves as a good light value midtone to judge the warm and cool of the flesh tones.

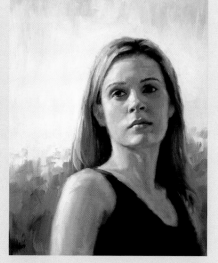

Complete the Work
For me, this is a cold and mechanical way to work. Effective, yes, but I like to push around paint and respond to what it does as one stroke is placed onto another. The most fun for me in doing this painting was painting the sky and background trees.

The Painterly Approach

When I began to study painting and attend workshops, I took several courses that were taught by linear artists. At the time, I didn't know about the different painting approaches, and because I had a hard time in these classes, I thought something was wrong with me. That all changed when I realized that what comes naturally to me is the painterly approach.

The painterly artist sees the world as dynamic, asymmetrical, and perhaps a little cockeyed. Mass rather than line is used as a tool to stress pattern, "lost" edges, shapes and masses, and the merging of subject and background. An object is defined as planes of color and value that represent its form as it relates to other forms. Objects in paintings may look like what they are, but it's OK if they don't. They aren't as important to the final painting as the overall effect. The viewer sees the painting as an artwork of unity and relative clarity with emotional impact from its gesture, not its subject.

The painterly artist's goal is to express an emotion and, in my case, a feeling for a time and place or mood. To accomplish this goal, the painterly painter only suggests detail rather than focuses on it, and emphasizes large, simple shapes and the relationships between them. The elements of color and value and the patterns they make are played up, adding progressively smaller and smaller shapes as the painting is refined. These smaller shapes create the impression of detail in the viewer's mind, but the subject is never drawn; the painterly artist merely creates marks that suggest it.

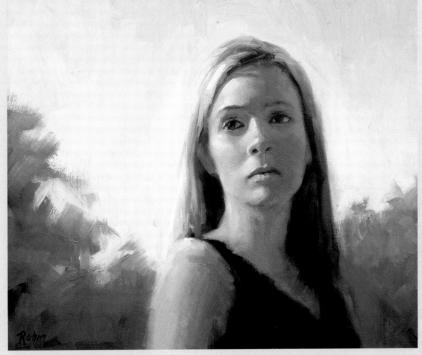

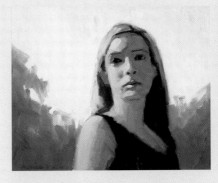

Define the Shapes Through Value
Using a no. 6 filbert and a no. 10 flat, rough in the main shapes, defining them by value. Try to make the shapes generally correct, but don't worry about the exactness of the drawing.

Refine to Your Tastes
The finished painting using the painterly approach is not quite as refined as the one using the drawing approach, but it could be if you wanted it to be. For my tastes this was carried far enough. It captures a feeling of the time and subject. Much of the expressive gestures of the painting process are evident, but not so much as to become a distraction.

I define each feature by a series of strokes of paint, not by drawing contours with the brush.

BE SELECTIVE WHEN CHOOSING A WORKSHOP
If the artist's work looks like a type you would like to create, you will probably enjoy learning her approach. If, on the other hand, you just think that she is a good artist, it's probably not a good idea to study with her. By all means don't go to a workshop just to accompany a friend. The wrong instruction could put you off track for months.

Drawing and the Painterly Approach

Now, let's talk about drawing as it relates to the painterly approach. When I said earlier that my goal isn't to create an accurate rendering, I didn't mean that drawing isn't important, because it is. To create a good painting you have to be able to draw, and drawing on its own is art. Painting and drawing are inseparable. You'll use drawing in every step of the painting process, from laying out the composition to placing the final accents of color.

When I paint, I want the viewer to be able to identify my subject, so my drawing has to be accurate. However, the principles I apply come from the realm of the abstract, from viewing my subject as shape, color and edges rather than as line and detail. So, in this context drawing doesn't mean putting lines around one object to distinguish it from another; it means measuring shapes and areas and carefully keeping their relationships correct. It also means placing a stroke where you want it and in the size, contour and direction you intend. If you get all the shapes and their relationships right, they will end up with a pattern of color and value that not only evokes emotion but looks like the subject without drawing a single line.

So how can you use drawing in your own painting? Before you put the first mark down on your canvas, look at your scene and study the shapes. Evaluate these areas:

Angles. What is the angle of this shape's edge, and how does it relate to the angle of this window or tree line or road?

Size. How big is this shape, and is it larger or smaller, more curved or more angular than the other ones?

Relationships. What is the color temperature and where is the black and white value of each area? How defined are the edges of the shapes?

Make an effort to paint what you see, not what you know. Don't paint a tree a certain way because you know that it is a pine tree. As soon as you begin to think of a thing for what it is, you begin to paint what you know of that thing and to lose sight of its relationship to other objects. You begin to draw edges and borders. Instead, paint that tree as a certain shape of a certain color and value, and, above all, relate it to the other shapes in your scene.

To help you find these relationships, here are some steps you can take:

- Find your horizon line. To do this, hold your brush at arm's length, horizontally and level with your eyes. The brush automatically marks the horizon line.
- Observe how all the parts of the scene relate to your brush. You will see quickly how much the side of the mountain or the edge of the river slopes.
- Sketch the horizon line a bit above or below the middle of your painting surface.
- Begin laying the shapes as you see them in relationship to the horizon line. As you lay in the masses, frequently check your work. Use the tip of the brush again, held at arm's length, to compare and measure shapes.
- Transfer these size relationships to your painting. (If you take your time in making these relationships accurate, you won't have to correct your proportions so much later. Also, your painting will feel more authentic to your subject, whether it is a landscape, still life or figure.)

Painting on Location
Suggest masses without using a critically defined contour drawing.

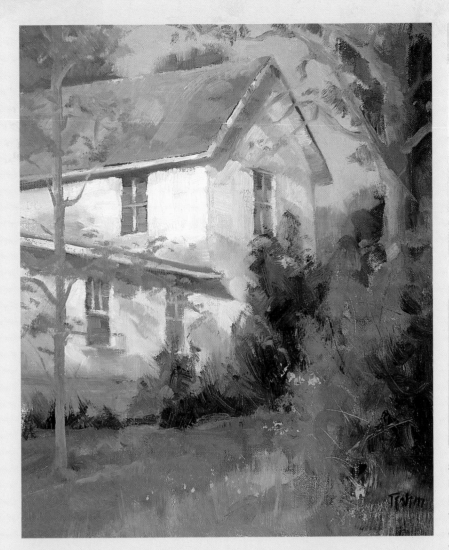

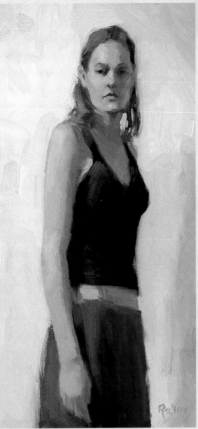

Suggest Objects Instead of Drawing Them
Rather than drawing the objects of a scene, try laying in large abstract shapes of color and value, progressively modifying them until you have a painterly suggestion of detail.

STANDING TALL
Oil on linen panel, 12" × 6" (30cm × 15cm)

Perspective
You don't have to understand perspective to draw well, but it doesn't hurt. You do, however, need to learn to see shape relationships accurately.

WHITE HOUSE
Oil on linen panel
12" × 10" (30cm × 25cm)

As you lay in your subject, focus on its essential characteristics—shape, contour, color, value and its relationship to other shapes—not on its details. Keep the edges of the masses soft so they can more easily be pushed and pulled as the work evolves.

Now that you have placed the subject in the painting, ask yourself if the composition works. Concern yourself with the overall design of your painting, not the illustrative details of the subject. This is the painterly approach.

Of course, this takes practice. The more you paint, the better you will be able to draw, and the better you will be able to see and execute every aspect of the painting, from composing to using color and value in a pleasing way. It has been said that you have to paint miles of canvas before you're any good at it. I've found this to be true. I like to think that every year my work and skills get better, and I'm well past a thousand miles. If we ever stop growing and learning, our work stagnates.

As a final word on drawing, let me say that line is not only a technique of the draftsman but can be used very effectively by the painterly painter. The Abstract Expressionists of the mid-twentieth century used line as a form of gesture to express movement and emotion. Paul Cézanne used line to flatten the three-dimensional illusion of traditional, illustrative scene painting and to separate shapes. Line is just another tool in your toolbox, and, if it will help you accomplish your goal, then feel free to use it.

The Painterly Approach to Figure Painting

One of the beauties of painterly works is the push and pull that occurs as the painting is developed and the shapes are modified and refined. Starting with a tight, exact drawing can be confining and results in stiff, unemotional paintings. It works for some artists, but for me the painterly approach is best.

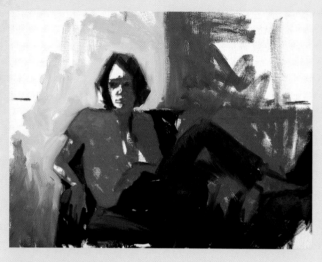

Lay in the Figure Study
Following a preliminary drawing in my sketchbook, I laid in this figure study. Though the model's head is located in the ideal location for the center of interest, I found it boring and ordinary, so I scraped off the paint and started again. If this were started as a very exact and time-consuming drawing, the emotional aspects of the design of color and value masses may not have been realized until after much work.

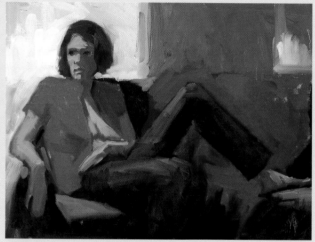

Work Out the Design, Color and Value
The second lay-in shifts the model farther to the left and she looks out of the canvas, something that proper design tells us not to do, though I found the tension exciting. The use of painterly brushwork and value pulls the viewer's attention back to the right with visual interest.

The major shapes have been painted in their average colors and values with thin washes. They are generally correct, but not exact.

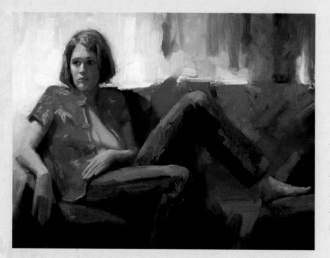

Direct the Viewer
The viewer looks at the model's face first, then visually travels down her bright red shirt to her hand surrounded by dark. From there he is drawn to the right along the leg in light to the light foot against dark. Next, he looks to the upper right because of the bright color and gesture strokes of light value contrasts, and follows the top of the sofa back to the model's face.

You are in control of these elements when you paint. If the model's foot were painted in shadow or the edges of her arm were too sharply defined and there were not the splashes of light value and bright color to the right, the viewer would follow the model's gaze right out of the scene and the picture would fail. Manipulating edges, color and value as you strengthen the design and emotional qualities is key to the painterly approach. Don't copy the scene, orchestrate it!

Carefully Suggesting Details

Whether you are drawing or using the painterly approach, locating the horizon line and the orientation of angles such as rooflines is crucial to the suggestion of the subject. It's also necessary to carefully evaluate the need for suggested details, or their elimination, to balance the visually decorative qualities of the painting. This is a very subjective balance that the painterly artist needs to practice. Don't be timid about adding or subtracting suggested details to enhance the overall work. Let the painting speak to you and don't be controlled by what is in front of you.

Materials

OIL PALETTE
Cadmium Yellow Light • Mono Orange • Burnt Sienna • Perylene Red • Ultramarine Deep Blue • Viridian • Titanium-Zinc White

BRUSHES
No. 6 hog bristle flat • no. 2 hog bristle extra long filbert

SURFACE
Oil-primed linen on board

OTHER
1-inch (25mm) painting knife • mineral spirits

1 Find the Horizon
Before starting a painting it's a good idea to locate the horizon and transfer that to your canvas. Holding the brush level with your eyes and at arm's length will show the horizon line.

2 Relate the Shapes to the Horizon
Locate the horizon on the canvas. Establish this reference to get the shape placement you intend for the scene, and relate all shapes to it.

REFRESH YOUR SKILLS BY TRYING SOMETHING NEW
I paint mostly landscapes (and teach landscape painting), but I also attend a weekly figure painting group and paint figurative work from time to time to practice with various subjects. It keeps my mind and skills fresh. Most artists not only work in more than one medium, but also in more than one subject. It's a good idea, as it keeps you balanced as a painter.

3 **Check the Angles**
The angle of the roof was important to me, so I found it using the handle of the brush and transferred it to the painting.

4 **Check the Edges**
Be careful not to change the angle of your hand as you move the brush handle down to the painting and check the roofline you have laid out. Since the peak of the roof is the most dynamic edge in the scene, make sure it's correct in relation to the other elements.

5 **Compare Size Relationships**
Use the end of the brush handle and your thumb to measure important shapes, then compare that measurement to other elements such as the length of the roof. Learn to measure and compare the size relationships within a scene.

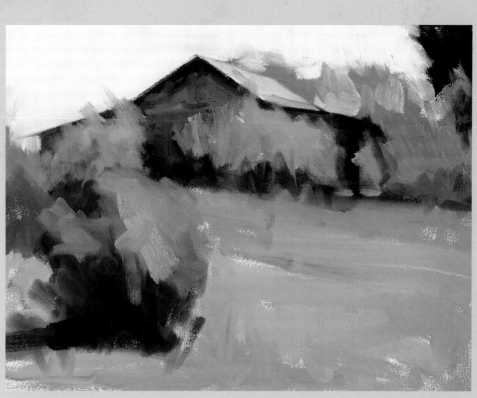

6 **Rough in Colors**
After finding the size and placement of the main shapes, rough in the masses of color.

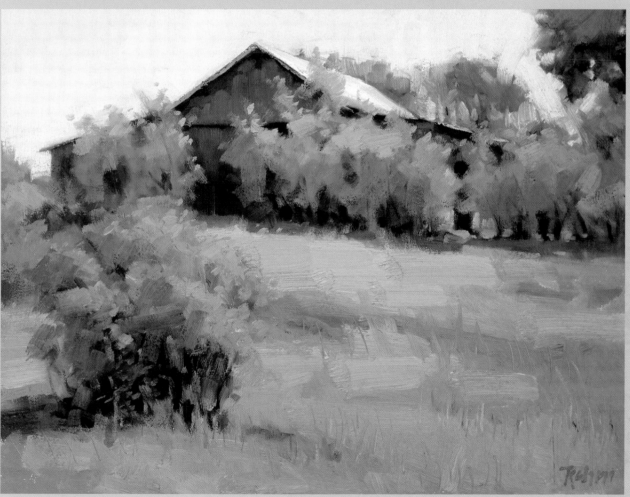

7 **Evaluate for Interest**
When the painting was finished, I thought the foreground grasses were plain and a little boring.

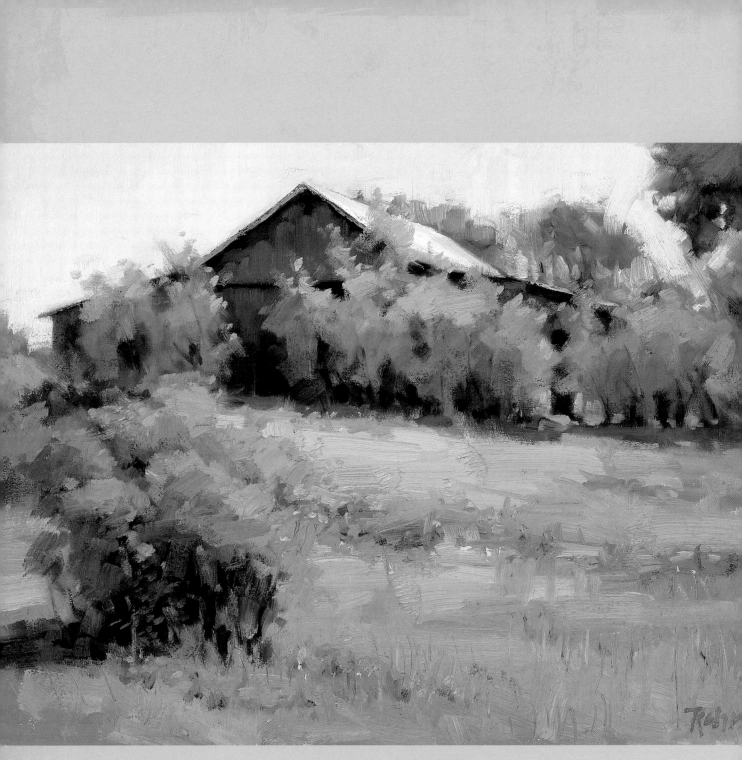

8 **Complete the Painting**
I added the suggestion of spring wild flowers for a more interesting field and to introduce colors I used in the upper part of the painting.

HOME COUNTRY
Oil on linen panel
12"× 16" (30cm × 41cm)

The Poetry of Painting

Once you've roughed in your subject and you're satisfied that your relationships are correct, what next?

First, stop sketching! If you get too hung up on detail and the exactness of the sketch, your painting will become boring because it tells too much. The viewer doesn't need to look at it again because it revealed all it had to say in the first glance. Remember, the goal—and the challenge—is to communicate a sense of time and place and to evoke emotion through the abstractions of color and value alone. Leave it up to the viewer to add the beauty of detail to your painting. This is what I call the "poetry of painting."

Another aspect of painterly painting can be found in the work of the Impressionists. Because light is the only thing that stimulates the eye, these artists sought to paint not things but the light reflecting off them. If you paint with this idea in mind, you will find yourself automatically painting shapes and relationships, not lines and objects.

Cézanne took this a step further. He painted three-dimensional objects as simple planes with certain relationships to one another. This kind of abstraction removes objects from any depiction of reality and deals with elements as pure form related to form. His approach "flattens" the landscape (or figure or still life) into a pattern of shapes of color and value. You can do the same by squinting at the scene before you. Squinting reduces the amount of light entering the eye, so it both flattens and simplifies the scene into a few simple shapes.

Orchestrate the painting. The eye is drawn to edges and contrasts, so control them to involve the viewer in the work and give them room to use their imagination. This is the poetry of painting. Painting every detail is like writing a technical manual. It may be done very well, but it is not emotionally stimulating for you or the viewer.

Finally, pay attention to how you actually apply paint to canvas. Painterly painting requires texture and brushwork. Don't strive for the smooth "finish" that the nineteenth-century French Academy artists believed was necessary to bring a painting to completion. Yes, apply your brushstrokes precisely and with control, but, once you put them down, thick or thin, rough or smooth, let them be unless it is to soften an edge or surface-mix the colors.

As you work, vary your paint from thin, transparent darks in the early

Paint Texture and Depth
Depth is conveyed with thick and thin paint textures. In the distance, all edges are soft and the paint layers are thin compared to the sunlit grasses in the middle ground. Much can be communicated about a subject through the variations of brushwork and texture while keeping value contrasts similar.

BLUE VISTA
Oil on linen panel
16"× 20" (41cm × 51cm)

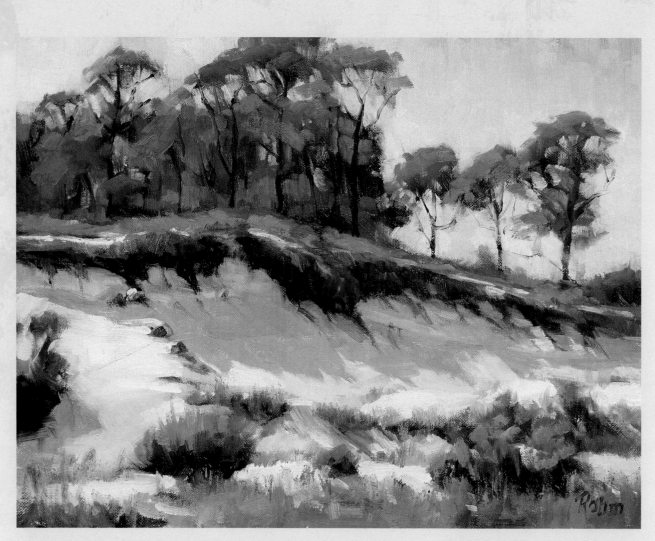

stages to opaque and thicker strokes in the later stages. Don't be afraid to scrape back an area with the palette knife and paint it again. The gesture of your strokes is crucial to the success of a painterly work. Don't blend away your brushstrokes. Blending may make the painting look more photographic, but it removes a major element of your expression and muddies the color. Brushstrokes can be—and should be—as distinctive as your own handwriting.

Be proud of your brushwork and let it show!

Emphasize Light

Painterly painting makes use of thick and thin paint to express the gesture of the artist and emphasize the variations between thin, transparent shadows and thick, opaque lights, as in the sunlit sand on the slope of the dunes in this painting. You can see the reflected light on the bank in the shadow as a change in color temperature more than a change in value. Too much value change would make the shadow shape busy.

DUNE
Oil on linen panel
12"× 16" (30cm × 41cm)

AN EXPERIMENT IN SEEING

Find something in the room that interests you, say, a vase of flowers, your coffee cup or a glass of wine. Let your eye rest on it without moving. Your eye will see the detail of the vase and flowers—the sharp edges of petal and stem, the sharp edge of the vase. Now, while your eye is still resting on the vase, try to sense what lies beyond it. You sense the table, perhaps a chair behind it, but all you can really see is the general shape, not the details. Highlights are blurred, edges soft. This is how the painterly artist sees and paints.

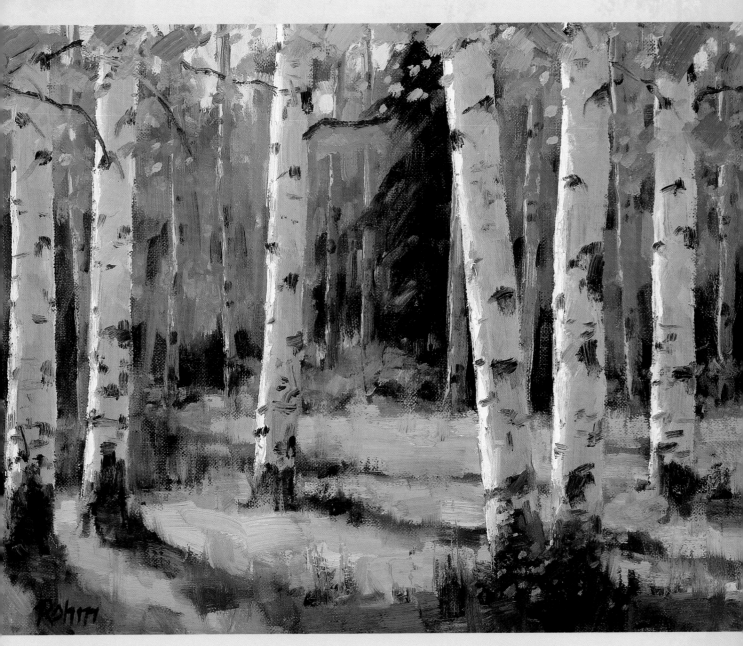

Balance Colors

The rhythm of spacing and the slant of the tree trunks keep the viewer in the painting. The outsides of the trees are leaned into the painting. The background, although full of texture and color, recedes behind the trees of the middle ground because there is less value change, smoother and thinner paint and grayed color compared to the trees in the foreground.

The thick, opaque textures and brushwork in the light areas complement the less aggressive color and texture of the shadows and distance.

Even though we don't see much sky, we understand that it is a clear, bright day because of the sharpness of edges and contrast between light and shadow. Also, a lot of blue sky is reflected into the flat plane of the shadows. The trees are warmer closer to the ground and cool as they grow to the sky. This happens with all trees, but it is more evident here because the light trunks of the aspen trees reflect so much color.

SUMMER ASPEN
Oil on linen panel
12"× 16" (30cm × 41cm)

3

Fundamentals of the Painterly Approach

A good painting draws us in, leads us on a journey and fills us with emotion and thought. The fundamentals of constructing a painting are the tools of the artist's trade. The skill with which you use them impacts your finished works. You must learn and fully understand these fundamentals so that they become second nature when you're creating a painterly painting. The basic fundamentals are relatively simple on the surface, but you can spend many years perfecting them and pursuing their finer points. For a work of art to be considered successful, the viewer must not even be aware of any of these fundamentals. The finished work stands complete.

EARLY SNOW
Oil on linen panel
24" × 30" (61cm × 76cm)

Composition

Composition is one of the most important elements of a successful painting, especially when using the painterly approach. Every painting has a composition, good or bad. As soon as you place a mark on a blank surface, you have set up a relationship of size, shape, placement, direction and value.

In my opinion, composition is the major problem of most works that fail, yet few people recognize this. Whenever I visit a non-professional exhibition, the number one problem I see is composition. The artists seem to be focused so much on color and drawing that they forget the structure of their pictures.

There are many principles and formulas for good composition, but the biggest trap most artists fall into is that they interpret these principles as rules, and the formulas as a requirement for painting. If I haven't made it clear already, let me make it absolutely clear now: There are no rules—just principles. When used, these principles work, but they are not always the best solutions for your interpretation of a particular scene. And there are definitely no formulas to follow unless you are trying to follow a particular school of Old Masters.

It's a good idea to understand the formulas used by the Old Masters, but these should be used as tools to help you express your ideas about a scene, not as the basis of how you portray it. Focus on learning the basic principles of good composition. Use the principles to guide you in your interpretation or to get yourself out of trouble, but don't become a slave to them.

Some of the most exciting works I see are in violation of the "rules." But the paintings work. (Not always, but when they do, it is exciting to see.)

A good composition is a pleasing arrangement of shapes, values and colors. Anything that aids this arrangement is useful, and brushwork, colors, values, textures and busy shape patterns that do not aid it should be eliminated.

Ask yourself, "What do I find most interesting about this scene? Where would that look best placed within this canvas? What size should it be? How much space would enhance what I find interesting? How important are the surrounding elements to this area and how much of them should I include? What shape and orientation should the canvas be to enhance my ideas of this subject?" All of these questions will help you establish a good shape relationship.

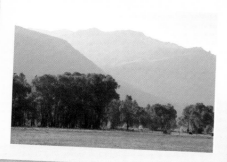

Reference photo

Study Based on the Photograph

When you look at a scene, try to break it down into no more than six or eight shapes—fewer if you can. These shapes are defined by color (dull or intense, warm or cool) and by value. Try to limit these shapes to only four or five values (see pages 44–45). You may end up with two shapes that are the same value, but they will be separated by color. Use a small sketchbook and pen to practice seeing these shapes.

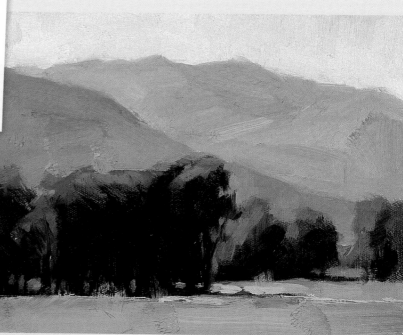

Study

Other important questions to consider before making the first mark include: What are you trying to do with this subject? Are you documenting the scene as it appears or are you creatively interpreting it to express a particular feeling?

I often approach artists in workshops and ask them why a tree, rock or other object is placed where it is in their painting and why it is painted with so much importance. The overwhelming response is, "Because it's there." If an object is not the reason you're doing the painting, then it has no business being there.

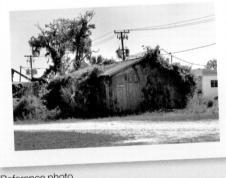

Reference photo

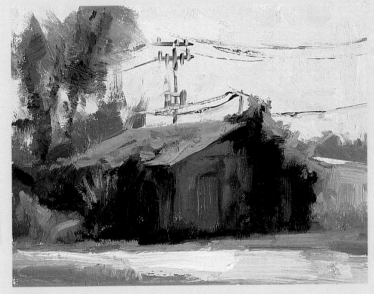

Study

Studies Based on Photographs

In these studies, see how the shapes and values of the photographs were simplified to create a dynamic organization using four basic value groups and warm and cool colors. The contrast of warm and cool colors and values is the strength of these scenes, so it is important that the structure is not lost as color, brushwork and details are added. The challenge is to maintain the dynamic simplicity of a small study in a large work.

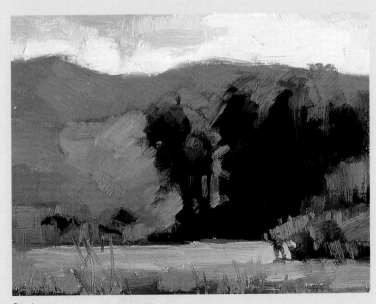

Study

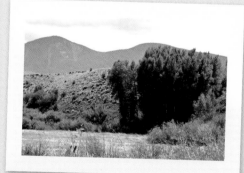

Reference photo

Balance

Good composition is about balance: balance of shapes (positive and negative, large and small), values (dark, mid and light), color harmony, intensity, dominance of warm or cool hues, and information (how little or how much).

Study the works of other artists to see how they handled what may appear to be a busy or detailed scene. Andrew Wyeth is a master of simplifying shapes and organizing their pattern to enhance the mood and his idea. Most people respond to the detail of his works and think that the drawing is what they are all about. It's the effective use of abstract shapes, color and value that make his paintings so compelling. Many other artists are more technically accurate; it is the underlying structure of Wyeth's paintings that makes them so effective. His father, N.C. Wyeth, a commercial illustrator, was also a master at using shapes to compose and capture his idea for the scene. I recommend that you study their works and those of other artists with this concept in mind. The impressionist western and landscape paintings of James Reynolds are particularly worth studying to see the effectiveness of good shape, value and color in design.

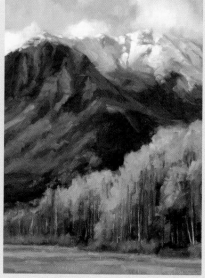

Composition Choices
The seemingly simple process of selecting the paper or canvas greatly affects what you say about the subject. Should it be a vertical, horizontal, square or panorama? All are viable options for you to consider, and the choice of which one to use will have a dramatic effect on the idea you are trying to convey and the way you will balance the object within the painting.

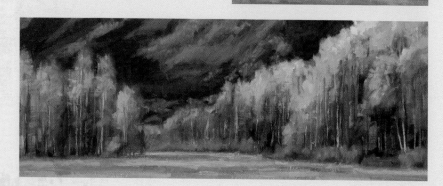

Placing the Center of Interest

There are principles and guidelines for achieving good balance within a painting, but it's good to remember that these are principles that work, not rules that you have to follow. Personal expression and balance of the elements are what matter most.

The biggest problem with placing a center of interest in the middle of the painting is not necessarily its location, but rather the balance of the other shapes. If you create an effective relationship, there is no reason that the center of interest can't be in the middle of the canvas.

However, if you center elements on a regular basis and then have a hard time making the whole painting balance, you risk making all of your work vignettes. I recommend getting into the habit of finding a better location at the start.

There are several formulas and methods for locating the center of interest. The golden section and the rule of thirds are the most common and time-tested.

To find the golden section of your painting surface, divide the horizontal and then the vertical dimension by 2.62 and draw a horizontal or a vertical line from each point. This will give you the ideal center of interest location for that particular size.

Or, simply divide your painting surface into thirds, and any one of the intersecting points is a good location for the center of interest. When starting a painting where I don't want the most dynamic place in my composition to be in the center, I simply mark off the thirds and place the most dynamic information close to one of the intersecting points.

Don't Center Everything
Good balance in a painting does not mean centering of all the elements. This is boring and creates uninteresting negative space.

Create Visual Weight
Finding the balance of various objects by how their weights counter one another is most visually interesting and creates interesting negative shapes. Balance by visual weight, not by centering elements.

The Rule of Thirds
Divide the surface horizontally and vertically by thirds. The resulting four intersecting points are each a good choice for locating your center of interest. It's up to you to choose the one that works best for your scene. If you are having trouble placing your center of interest, starting this way will solve the problem. This simple approach works for any format. I do this with a brush and paint before starting to lay out the shapes.

Keep the Viewer Interested

Accents in a painterly painting can be as simple as direct or bold strokes. These strokes are focal points that attract the viewer's eye by their characteristics. Use these accents to create a path of either light or dark that guide the viewer's eyes into and around your painting, leading them to the center of interest. If you are attracting attention where you don't want it, simply soften the edges, values or colors and make them more dynamic where you want the viewer to look. This is one of the most important concepts of composition—creating a visual path, not just copying elements of your subject because they are there.

One of the keys of painterly painting is attracting the viewer to strokes of color, value and edges that may have no other purpose than to make the work more dynamic. This truly separates the drawer and the painter. The drawer controls the view by the representation of detail; the painter controls the view by manipulating paint, with or without any relationship to reality, but rather with a concern for good composition and visual flow.

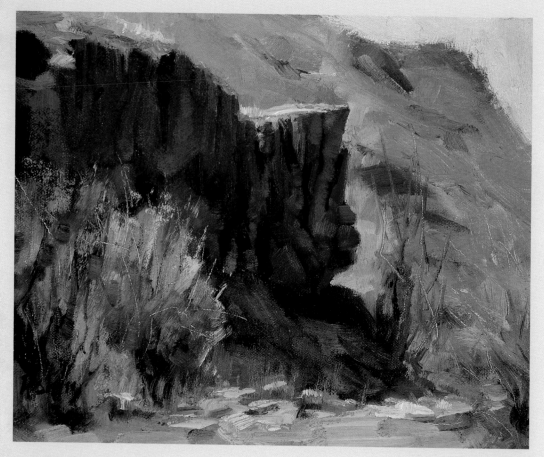

Orchestrate the Work's Visual Flow
Masses and accents are used to direct the visual flow within a work. Look for opportunities to link shapes of dark or light to organize and simplify the number of individual spots into a simpler design. It's easy to add complexity, so start as simply as you can. Here the lights visually guide the viewer's eye through the painting. The values of the large, dark mass are close to have one large, dominant dark shape. Too many value changes within the shapes would make the painting busy.

CANYON REFLECTIONS
Oil on linen panel
8" × 10" (20cm × 25cm)

Sketchbooks

It's a good idea to always have a small sketchbook with you so that you can sketch out compositional ideas, make notes or just enjoy doing a simple sketch when there is not enough time or it's not convenient to paint. I almost always carry a pen, but you may prefer a pencil. If you're not sure how to organize the shapes or create visual flow within a scene, do a small black-and-white sketch. This will quickly show the relationship of the masses and how you may need to alter them to make the painting work visually. It's a lot easier to change a five-minute sketch than a painting.

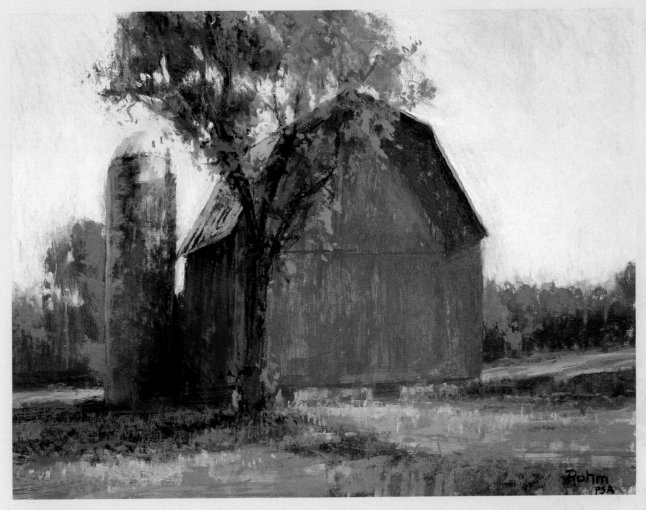

Don't Overdo It

Paintings with large, simple shapes that form a pleasing arrangement of positive and negative spaces tend to be the most visually interesting, regardless of the subject. The hardest thing for me to do is to leave a work simple and resist the temptation to clutter it with unnecessary strokes, value, color and drawing. Ask yourself what's really important and leave it at that, doing only what's necessary to state the idea. Here I kept the barn siding simple so that visual interest would be on the barn's color and shape as it related to the surrounding hues and not the building's texture. That would have been a different painting idea and the entire picture would have been handled differently to play up texture variations rather than shape and color.

A MICHIGAN RED BARN
Pastel on white sanded
pastel paper
12" × 16" (30cm × 41cm)

Value Is "Key"

The term *value* relates to the light and dark within a subject. Remember, all color has value. I used to think that I understood the use of value because I knew how to give subjects form by painting dark and light. Once I started to simplify and paint the nuances of value, however, this seemingly simple tool became very complex. It is an aspect I focus on every time I paint. I don't mean to scare you, because it is exciting. Every scene provides a new set of relationships to be considered and experimented with. So, learn the basics, then have fun controlling and experimenting with the many aspects of value.

Most painters limit their working values to nine—four in the light range, four in the dark range and one in the middle. More than that is too hard to manage, and it is better to simplify this range. Compared to nature, these nine are not many, but as artists we are trying to represent the effects of light, not copy it.

All Color Has Value
Learning to see the black and white characteristics of color is crucial to understanding the structure of your work.

Traditional Value Scale
As an exercise, make your own value scale. A nine-value scale is effective. If you try to create more values than that, the changes become awkward and too close. This scale was created by simply mixing black and white oil paints.

A LIMITED VALUE RANGE EXPERIMENT

A good experiment and practice for this simple value concept is to mix a series of warm colors in all four value groups, and then mix a series of cool hues in a matching group of values. Using these eight colors, paint the landscape. Don't mix new hues as you work. Force yourself to place parts of the scene into one of these warm or cool values. You will quickly see how effective the limited value range is in creating a dynamic painting.

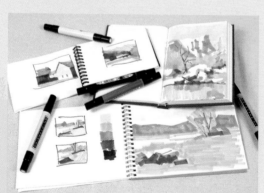

Experiment in Your Sketchbook
Keep a sketchbook close so you can do value studies. Whenever you struggle with the organization of the scene, make a few quick sketches with pen, pencil or marker.

KEEP VALUE SCALES HANDY

Once you've made a few value scales, keep them nearby and use them to evaluate your paintings and compare color mixtures. Place them in a plastic bag and lay a color mixture directly on top of the value to see where the mixture falls.

44

Four-Value Approach to Painterly Painting

Back in the 1930s, John F. Carlson proposed that only four values were necessary to interpret the complexity of the landscape. He proposed the sky as the source of light is the lightest value; the flat plane of the land that catches light most directly is the second lightest value; the slanted hills and mountains that catch light at an angle are a dark middle value; and the upright planes such as the trunk of a tree are the darkest.

All things being relatively equal, this four-value landscape concept holds true (though there are always exceptions, such as a light, sandy beach, snow or light-value buildings). Even with these exceptions, however, the relationship of value planes and source of light is the same. For example, a light sidewalk catches more light than the light side of a light-colored building and would be a lighter value. Also, a dark cast shadow on the ground is filled with the reflected light of the sky and is never as dark as an upright shadow.

Keeping the Carlson four-value landscape in mind, always try to simplify your scenes into these values—five value groups at the most. There are many ways to simplify. For example, a distant tree line may have both light and shadow, but, for the strength of your painting, you need to keep the tree line the same value. Instead of adding another value, represent the light and shadow by using warm and cool colors, keeping their values the same. Limiting yourself to four values at the start will help you control your painting.

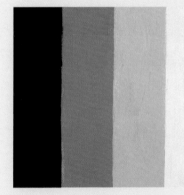

A Simplified Value Scale
I try to simplify my work into a four-value group, but always save a little room for a very light or very dark accent. Don't use your maximum range; save room to add accents if needed. Otherwise you may find it necessary to repaint and revise areas to make your accents work.

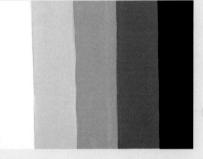

A Five-Value Group Is Sometimes Necessary
While I try to limit my painting concepts to four value groups, it is often necessary to use five. The more you can simplify your values, the more unity your painting will have. The primary cause of a busy work is too many values. Simplify, simplify, simplify and organize the grouping of these values.

FOUR-VALUE LANDSCAPE
The sky is the source of light and therefore the lightest value mass. The flat plane of the ground catches light most directly and is the second (or light-middle) value group. Slanted planes catch light at a glancing direction and are the dark-middle value mass. Uprights such as tree trunks catch the least light and are the darkest value group. There are exceptions to this concept, but you must always be aware of this relationship.

Create Value Studies

Many great paintings through the ages have been created using a very limited value range. Through practice, you'll find that the four- or five-value scale is all you need for dynamic yet subtle painting.

Whether you're in the studio or on location, doing value studies will help you evaluate a scene, determine a value structure or discover if there is a good pattern of light or dark. These studies greatly aid in determining which value group you want to shift an area to for simplicity. It may take several sketches or studies to work this out, but you'll find the effort is worth it.

The three examples on this page show how the four-value concept is applied to different landscapes.

THE "VALUE" OF SQUINTING

When you squint, areas and textures of similar values merge into simple masses of an average value. By comparing simple masses of dark, medium and light in your scene, you'll find an effective structure for your painting. Squinting also eliminates unnecessary detail information and reveals the most dynamic edges, which are the ones you want to paint. These stronger edges generally happen where there is a stronger change of value.

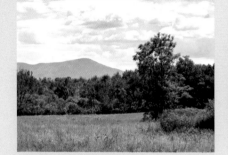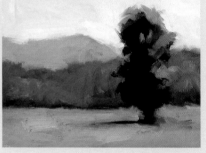

Classic Four-Value Study
Here, the sky is the lightest value and the upright tree is the darkest. The tree line is the dark-middle value, and the distant hazy mountain and the grassy field are the light-middle value.

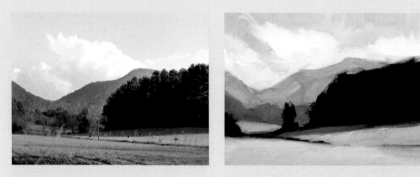

Sky and Land, Same Value
Here, the clouds are the lightest; the near tree line uprights are the darkest. The distant tree line is the dark-middle value and the field, the distant hazy mountain and the clear area of the sky are the light-middle value.

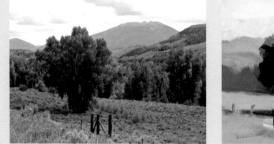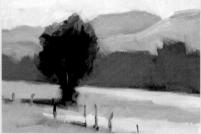

Land and Sky, Lightest Value
In this value study, the upright tree is, again, the darkest mass while the sky and part of the ground are the lightest. The distant tree line is a dark-middle value. (I would paint this tree line with warm and cool colors to show light and shadow, making sure that the value remained the same according to the value plan.) Part of the field and the distant mountains are the light-middle value.

Painting with a Value Plan Is "Key"

As painters working with a limited value range, we must force our work into one of the three value keys: low, mid and high. One of these three needs to dominate your painting, while the other two are subordinate. Whichever you choose, don't let the others sneak in and create conflict. One must dominate. Don't confuse the value key. It is much more effective to slide and simplify values to fit one of the three keys than to expand the value range you are working in. Simple is better.

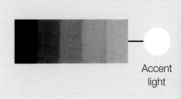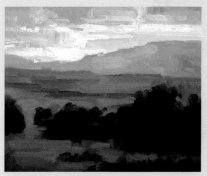

Accent light

Low-Key Value Dominance
In this low-key painting, the majority of values are from the middle to the dark end of the value scale. Although I used the dark end of the scale, there are accents that fall at the lightest value. Every good painting contains a full range of value from black to white even though the work is dominated by one of the three value keys. This scene could also be described as a large dark with small light.

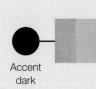

Accent dark

High-Key Value Dominance
In scenes like this snow scene or a white, sandy shore, we are presented with a range of value that is very high-key, toward the white end of the value range. As with the low-key, you need to let the key that you are working in dominate. Don't add too many dark-middle values, but make sure your painting contains accents of dark that range all the way to the darkest end of the value scale.

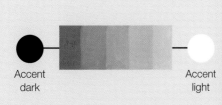

Accent dark

Accent light

Mid-Key Value Dominance
Most of the scenes we encounter fit into the middle key. As with low- and high-value keys, simplify and limit the values. Use accents of dark and light at both ends of the value scale. You can see in the sample above that the light flowers on the end of the plant are a white accent and the dark, shadowed trunks of the plants are a dark accent.

Value and Edges Describe Form

We all see areas of different value within the overall mass, but when little thought is given to where the edges are soft, where they transition from dark to light, and where they are hard and separate, the mass will be chaotic, flat and confusing to look at. As a painter, it's important to learn how value and edges are used to describe form.

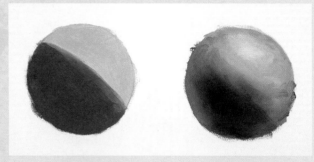

Use Value to Create Three Dimensions
It takes three values to represent three-dimensional form. A form with just dark and light looks two-dimensional. You can create a transition with more values by blending the dark and light together or by adding another value with paint.

Soften the Edges
The edges within a form must be soft. Edges that separate one shape from another can have a sharper edge and more dramatic contrast. Many times students see three or four different values in an area such as a tree, bush or group of rocks, and they paint strokes of these values, but don't understand or visually explain to the viewer what each value belongs to. This makes the painting look busy and confusing.

Create Visual Understanding
Here you can see that by softening the edges of value changes within the form, you start to have a visual understanding of how the value is used to describe form.

Relate the Forms
Now you can see how the value edges have been softened within each form. The only hard edges are the ones that happen naturally between objects. Again, any time you place a stroke, ask yourself, "What does it belong to? What part of what form is it describing? Should the edge be hard or soft?"

Color: The Emotion of Painting

I've heard it said that "Value and composition do the work and color gets the credit." For the most part, that is a true statement. Color is the emotion of painting. While the emotion of a painting is critical to the success of that work, the fundamental elements of good design, value and execution are equally or even more important. We all see color a little differently, but we all must understand and use the same principles of color to find and mix the ones we want.

You need to learn the concepts of the color wheel so that you can look at any color and identify where it would fall on the wheel and understand its relationship to other hues. Next, you must learn how to mix that color with the hues on your palette.

It's important to understand the basics so that when I discuss certain color mixes and uses you know what I mean. Beyond the basics presented here, color mixing and use is a matter of personal preference.

The color wheel is made of primary, secondary and tertiary colors. Each has the properties of hue, value and intensity.

- **Hue** describes the color and where it belongs on the color wheel. For example, red-violet describes a color that is on the violet section of the wheel approaching red.
- **Value** is the black or white quality of the color. It's how dark or light it is.
- **Intensity** is the degree of vibrancy a hue has and to what degree it may be grayed by its complement.

- **Primary colors** are red, blue and yellow and, in theory, are the only hues we cannot create from a mixture.
- **Secondary colors** are orange, violet and green and are made by mixing two primary colors.
- **Tertiary colors** are created by mixing a primary and a secondary color. For instance, red-orange is a mixture of red and orange.
- **Complementary colors** are hues that are directly opposite each other on the color wheel. Red is the complement of green, blue is the complement of orange, and yellow is the complement of violet. In theory, when combined in equal amounts, they will produce a completely neutral grayish color mixture. This is especially true when you combine the three primaries. These mixtures will lower the intensity of the hues you are using.

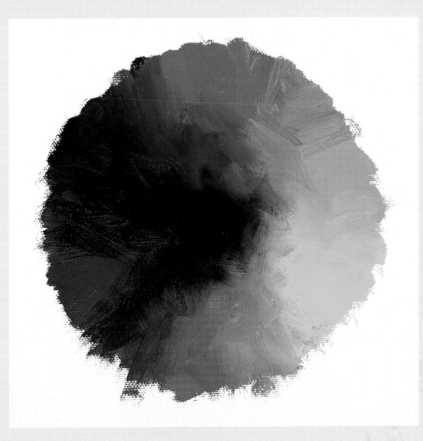

Make a Color Wheel
Make your own color wheel using Permanent Red Medium, Cadmium Yellow Light and Cobalt Blue for the primaries. Next, mix the secondary hues of orange, violet and green from these primary colors, then blend the mixtures together to transition around the outside of the wheel and into the center. It's a fun challenge to do it well. Keep your brush clean or use several brushes.

It is helpful to learn where the colors of your palette are located on the wheel. This will aid greatly in your understanding of what happens (and why) when they are mixed.

Three Uses of Color

There are three ways to use color in contemporary painting: tonal, impressionistic and open.

Tonal

Before the Impressionists emerged in the mid-1800s, nearly all painting was tonal. Artists were mainly concerned with depicting the dark, light and local color of a subject. This approach is still used successfully today and illustrates how important value and composition are to the creation of a work. Tonal works tend to rely on their mood or realism for their success, while the impressionistic and open-color approaches depend strongly on the emotional effects of color.

Impressionistic

The early Impressionists took their paints and canvases into the great outdoors and studied the effects of light and atmosphere on the subject. The Impressionists learned how you can see the local color of an object in neutral light, but, as that object moves into more direct light, its color is affected by the light's temperature. Conversely, as the object moves into shadow, it loses the color of the light source and is affected by reflected light.

They observed that typically there is a dominance of warm light and cool shadow. However, when reflected, light creates very warm shadows while the light looks cool. As artists we paint warm light and cool shadows or cool light with warm shadows. That's not to say that an element of each can't exist in both scenarios, but there should be a clear dominance of warm light and cool shadow or cool light and warm shadow.

Local Color
Local color is the natural color of an object when viewed in flat, neutral light. As soon as you see shifts in the temperature of light, or the reflected colors of the surrounding hues, it is no longer viewed as simply the local color.

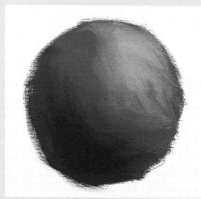

Tonal Approach
To take a tonal approach to the local color of red, add white to lighten the light areas and black or a dark color to darken the area in shadow. This classic approach has been used for hundreds of years for creating form and representing light and shadow.

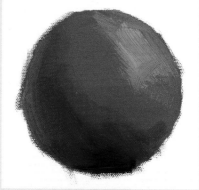

Impressionistic Approach
The Impressionists observed the effects of natural light on objects. As an object moves into light, it gets warmer, not just lighter. The shadow becomes cooler, not just darker. Using color and value in this natural way adds an immediate feeling of natural light. Notice how blue the shadow is and how orange the sunlight is.

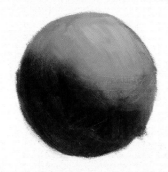

Open-Color Approach
Open color is the emotional and arbitrary expressive use of color with no relation to the natural, local color or the color of light and reflected hues. It does, however, still follow the principles of value and color temperature such as warm light and cool shadows or cool light and warm shadows.

Open

Open color is typical of the work of Henri Matisse as well as the German Expressionist painters of the early twentieth century. Their use of color was completely arbitrary and based on personal responses to their subjects. This can also be a viable choice of color usage for the painterly painter to create excitement and emotional impact. What is most important to observe and recognize with this approach is that correct value relationships are just as important as the use of color. If the value structure doesn't work, the most exciting use of color in the world will not save the painting.

Open colors are also used very effectively to accent a work. For example, the overly green landscape that most of us encounter can be dramatically enhanced by underpainting with complements or arbitrary color. Think about using red and orange hues or red and blue-violet hues for that otherwise green landscape. Consider placing a complementary color stroke next to a dynamic spot in the painting or adding life to a shadow with a stroke of pure red or blue.

Color Control

All of these color theories are acceptable, so it becomes a question of what approach you, as the creator of the painting, want to use. Whichever one you choose needs to dominate. Don't confuse yourself or the viewer with equal and mismatched effects of all three. Choose and work with one until you are comfortable with it, and then experi-

ment with the others. This could take years. Many painters have worked with just one of them for their entire career, so don't feel you need to change. Just gain control and understand why you are choosing the colors you are using.

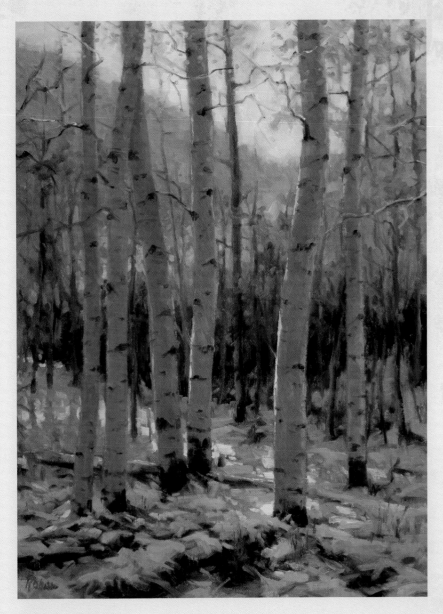

Impressionistic Color
Here, color is exaggerated to create mood and to heighten the contrast of warm sunlight and cool snow in shadow. The dark and light tones convey the reality of the scene while color is used for effect.

MORNING CALM
Oil on linen panel
24" × 18" (61cm × 46cm)

DOES THIS ACCENT WORK?

If you back up five or more feet (2m) from the painting and the accent enhances and does not distract or call too much attention to itself, leave it. On the other hand, if it is distracting, reduce or eliminate it.

Warm and Cool Colors

When you divide the color wheel in half (oriented with red at the top), one half is warm and the other is cool. Both red and green have hues of each temperature, while red-orange, orange, yellow and yellow-green are the warm colors, and blue-green, blue, blue-violet, violet and red-violet are the cool hues. Yellow is the warmest color, and blue is the coolest color.

So you have two references to warm and cool when describing color. As a painter, you need to consider the relationship of colors and not just their location on the color wheel. Ask yourself if a color is on the warm or cool side of the wheel and how it compares to the other colors in the painting.

Compared to blue, blue-green is warm, as is violet. Since pure blue is the coldest color, any color moving away from it is warmer in comparison. Pure yellow is the warmest color on the wheel, so orange is cooler since it contains red and is moving away from yellow. Yellow-green is cool compared to yellow, but warm compared to blue-green.

I can't tell you how crazy I thought my artist mentor and teacher Ann Templeton was when she told me to use a warm blue in the sky. "How can a cold color like blue be warm?" I thought. Once I understood this concept of warm and cool relationships, it was obvious.

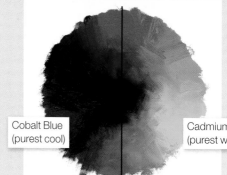

Cobalt Blue (purest cool)

Cadmium Yellow Light (purest warm)

COOL ⟷ WARM

Dividing the Color Wheel
Colors on the right side of the color wheel are warm, and colors on the left side are cool. Cadmium Yellow Light is the purest and warmest warm color, and Cobalt Blue is a pure, cold blue. Any other color will be warm or cool compared to these two.

Value Change Is Essential
The circle on the left shows warm light with cool shadows as well as tonal value change. The circle on the right also shows warm light with cool shadows but no value change. Use the approach on the left around your center of interest and in the foreground. Use the approach on the right when your value mass needs to stay simple. Color shows light and shadow, and value adds dynamics. Learn how to choose.

Transitional Colors
Combine warm and cool complementary colors equally to achieve a neutral dark. Use white to control the value of these mixtures when painting transitions between warm and cool hues. Placing a warm and a cool directly next to one another can be too dramatic, especially in any location other than the center of interest.

Grays and Browns
Any color on the cool side of the color wheel will make a gray, and any hue on the warm side will make a brown. Ask yourself what kind of brown or gray you need, what value it should be, where it's going and what it will be next to.

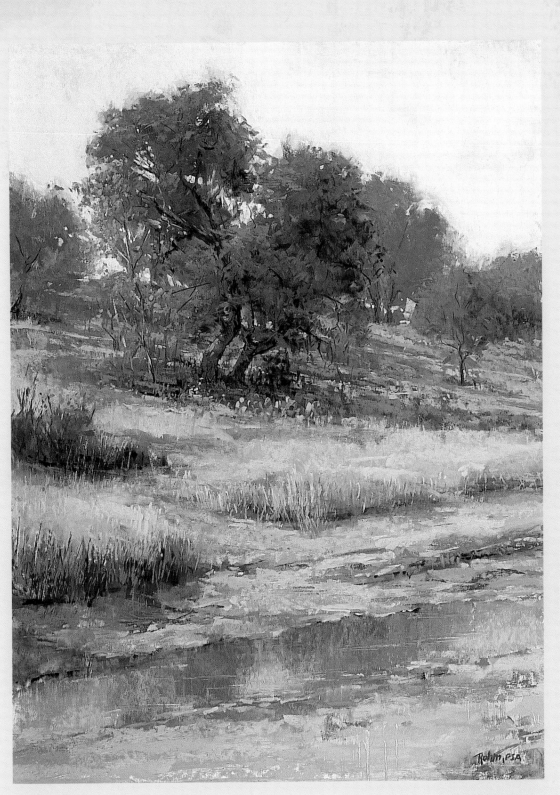

Light Contrasts

The contrast between warm and cool color is what makes us feel the light. The stronger the contrast of warm and cool, the brighter a day it will be. So, on an overcast day there will be very little warm and cool color change. Without the cool color we wouldn't understand how warm the light is. As in this painting, when we see very warm light, it makes the shadows cool as they reflect the color of the sky. The stronger and warmer the light, the cooler the shadows appear. However, when we see shadows full of warm reflected light, it makes the sunlight look cool. The normal situation is to have warm light with cool shadow, but the cool light scenario does frequently occur and is exciting to paint when it does.

SUMMER REFLECTIONS
Pastel on sanded paper
20" × 16" (51cm × 41cm)

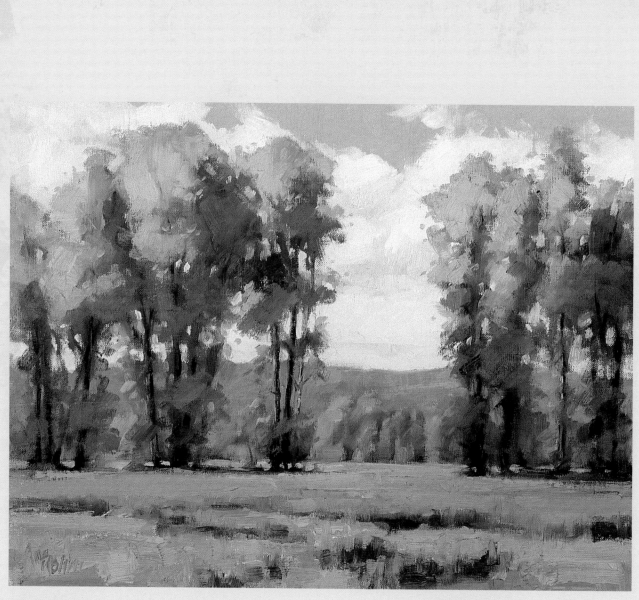

Warm Dominance
This painting shows the dominance of warm color. Most of the hues fall on the warm side of the color wheel. Emotionally, people respond more pleasantly to warm colors.

COTTONWOOD FALL
Oil on linen panel
12" × 16" (30cm × 41cm)

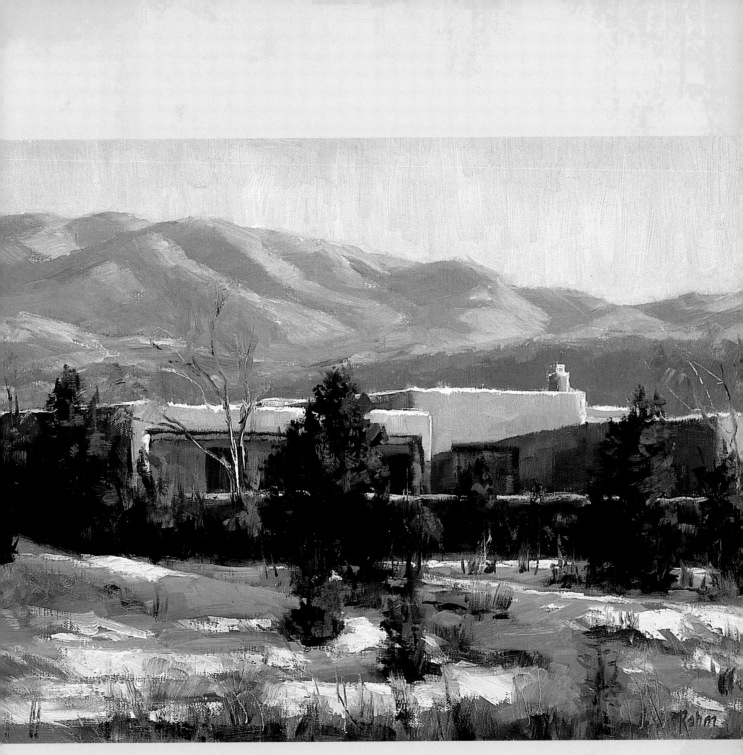

Cool Dominance

This painting is done in a dominance of cool colors. Viewers tend to find cool colors more mysterious and intriguing. The eye is drawn to the small section of warm color. This is due to size and contrast of color, but also because people are more attracted to warm colors.

WINTER MORNING
Oil on linen panel
12" × 16" (30cm × 41cm)

Color Harmony

For the most part, don't plan the harmony in your art; let it develop from your subject. Natural color harmonies are usually better than what we would invent anyway. Subtle harmonies in nature are wonderful and sometimes unexpected. What's more, they always work. These natural harmonies get messed up when humans start introducing colors and values into the landscape. Take, for example, a beautiful natural rural scene, and then envision man building a purple house. The color harmony is gone.

There are times when the harmony is enhanced by these extreme colors and that is what makes the subject exciting for us. Take, for example, a teal boat or building next to the Caribbean Sea. Or a red barn in a green landscape. They become beautiful complements to the natural environment.

As you step back to evaluate what you have done, ask yourself if the colors you're using are harmonizing. If they're not, and you're not sure what is out of balance, refer to one of the harmonies listed here, and force the colors of the painting into one of them. If your natural selections are working, leave them alone and just keep painting.

Complementary Harmony
A complementary harmony scheme includes any two hues opposite one another on the color wheel, with one more dominate than the other.

Primary Triad Harmony
A dominance of the three primary colors.

Secondary Triad Harmony
Orange, violet and green make up the secondary triad. This is actually the most used color harmony in landscape painting: green trees, cool violet shadows, and warm light grasses and earth colors.

Accent

Analogous

Analogous Harmony
This is taking a pie shape of color from any portion of the wheel to dominate the painting. A complement of the pie shape is generally used for accents.

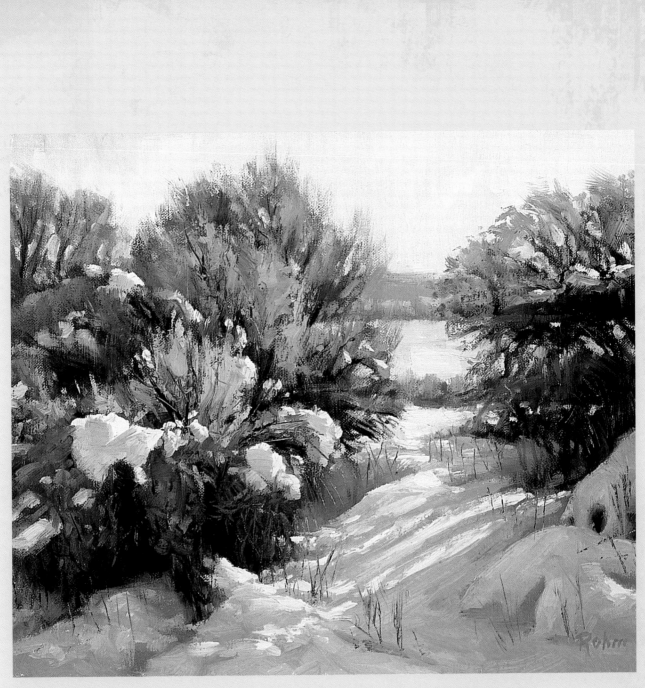

Winter Color Harmony
This winter scene shows a natural use of blue and orange complements to contrast the cold snow and the warm winter colors of the plants. Color combinations that work together within the painting and do not conflict with one another create effective color harmony.

WINTER COMPLEMENTS
Oil on linen panel
10" × 12" (25cm × 30cm)

UNPLANNED HARMONY

Color harmony is something that you should evaluate and adjust while you're painting. Don't control the scene; respond to it.

Color Intensity

Color looks intense when surrounded by grayed hues. If all the colors you use are bright and vibrant, they will cancel each other and you will be left with chaos. One color family should always dominate and the others should be subordinate.

An analogy I always use in this situation is if you went into a concert hall and the orchestra played the same note repeatedly for an hour, you'd go screaming from the hall. Well, that's the effect you'll create for the viewer if you don't orchestrate the colors of your painting. Take the viewer on a journey. Don't bore them with the same color everywhere.

The bottom line is that it doesn't matter how dull or intense you paint as long as there is variety and dominance within the painting.

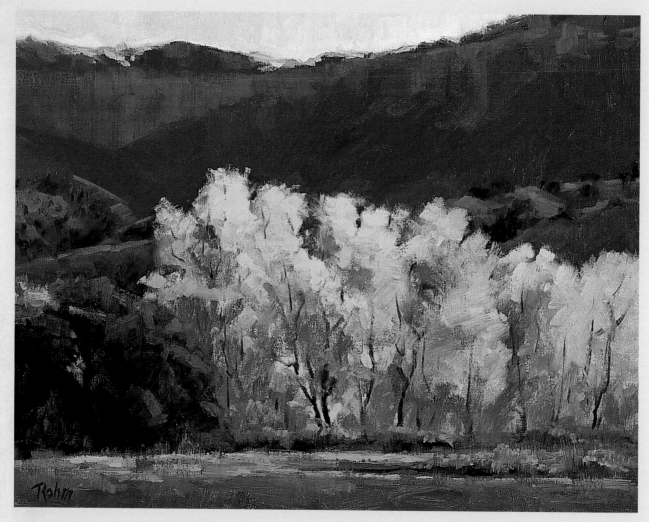

Competing Colors

When you are standing in front of them, the intensity of yellow cottonwood leaves in autumn sunlight often seems brighter than paint can achieve. It is very important when painting a scene with this intensity that the other colors enhance the intense hues and do not compete with them. Only one color family should be dominant.

MORNING COLOR
Oil on linen panel
14" × 18" (36cm × 46cm)

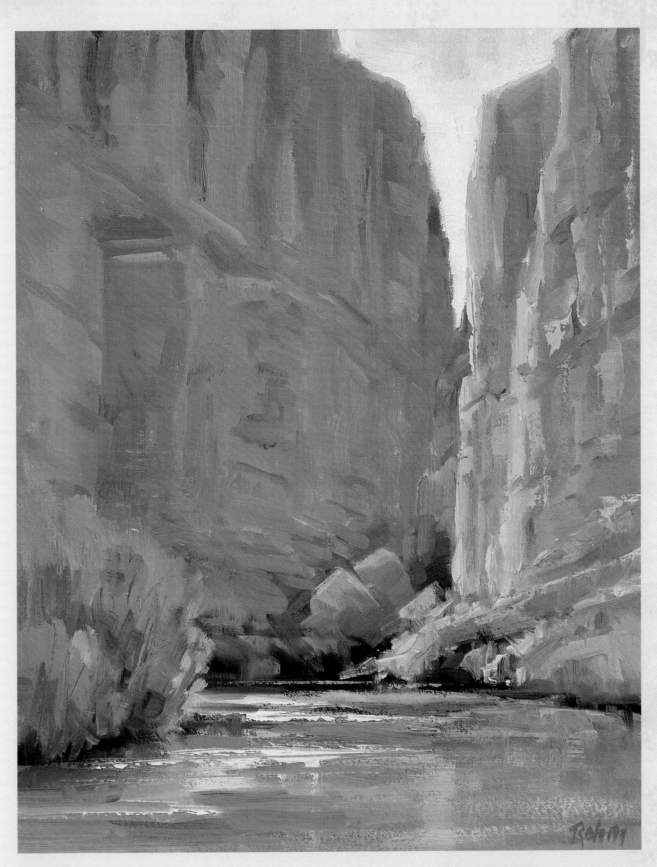

Muted Hues

This desert canyon scene is dominated by dull, muted hues. The only bright, clean color is the sky, which is a cool blue. The sky is clear and should feel that way contrasted against the soft hues of the desert rocks and water.

SANTA ELENA CANYON
Oil on linen panel
14" × 11" (36cm × 28cm)

The Limited Palette

Working with a very limited palette will teach you a lot about mixing colors. It will also nearly assure color harmony in your painting, since every color in the painting will be made from the few you're using. If you want to include a new color, make sure you use some of it in many of your color mixtures. Artists get into trouble when they add a new color to their work without having used it in other mixtures.

You may find that working with a large group of colors does not improve your painting. In fact, it will often make it too busy with color changes. Using a larger selection of hues should be done for convenience or because you want a transparent hue compared to the opaque ones that you're using or vice versa. For example, I usually work with Cadmium Orange purely for convenience because I use so much of it when I mix greens. But I can very easily make an orange by mixing Cadmium Yellow Light and Perylene Red.

My limited palette is derived from some basic principles: the importance of the primaries to mixing colors; warm and cool hues; and the purity of color.

Limited Palette
This palette is made up of Cadmium Yellow Light, Perylene Red, Ultramarine Blue, Viridian and Titanium-Zinc White. The primary colors are represented, providing the capability to mix any hue found on the color wheel. They won't exactly match the pure color wheel, but they will look similar, and all the color mixtures will harmonize.

Palette on Location
When traveling and working on location, the limited palette makes perfect sense. You don't have room to carry and use a lot of colors. By representing the three primary colors, you can mix a full spectrum of hues.

DRY WASH, BIG BEND NATIONAL PARK
Oil on linen panel
8" × 10" (20cm × 25cm)

Improved Harmonies

Once you have become comfortable mixing color with a limited palette, it will not feel restrictive and you will be amazed by the quality of your color harmonies. Color needs to become responsive to the evolution of the painting, and should not be something that you affect with hues straight from the tube.

LIMITING YOUR PALETTE

Use a limited palette to premix your colors. You can make orange or Yellow Ochre, or mix Viridian and Ultramarine Blue to create a Cerulean Blue. Teach yourself to mix secondary colors, and you will soon find that you can paint well with the limited palette.

The Limited Earth-Toned Palette

The Old Masters did not have the intensity of hues that are available today, so it is no wonder they tended to work tonally and painted with dark and light local color. Pure reds, blues and yellows were rare and very expensive. That's why paintings like Thomas Gainsborough's *The Blue Boy* were so dynamic for their time.

These artists worked mostly with colors like Naples Yellow, Venetian Red, and dark colors like Van Dyke Brown and black. While this palette seems very limited, it provided all that was needed for an effective tonal painting. The dull yellows placed next to black and gray create the feeling of warm and cool, and yellow and black form a green. Bright blue was accessible then and was sometimes added for depicting sky and water.

An Earth-Toned Palette
My limited earth-toned palette consists of Yellow Ochre Light, Venetian Red, Ultramarine Blue and Chromatic Black. This could be expanded to include Naples Yellow Hue, Burnt Sienna, Burnt Umber and Terra Verte, though I find the limited version works just fine.

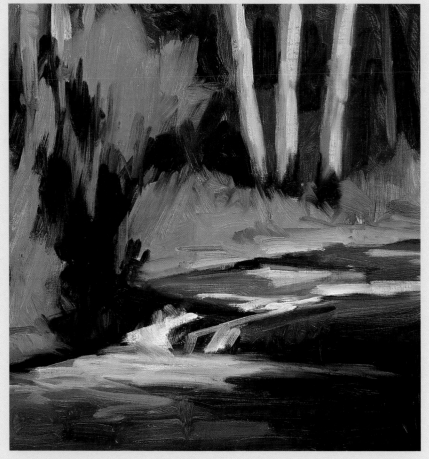

The Underpainting
Whether you use a full-color, limited or earth-toned palette, first find the main shapes and average the local color and value of each. It's a lot easier to modify these average masses than to blindly add hues, values and textures to a white canvas.

The limited earth-toned palette is calm and quiet. Although you still have all the advantages of warm/cool and dark/light, the colors are toned down. This is a great palette choice for creating intimate, quiet scenes.

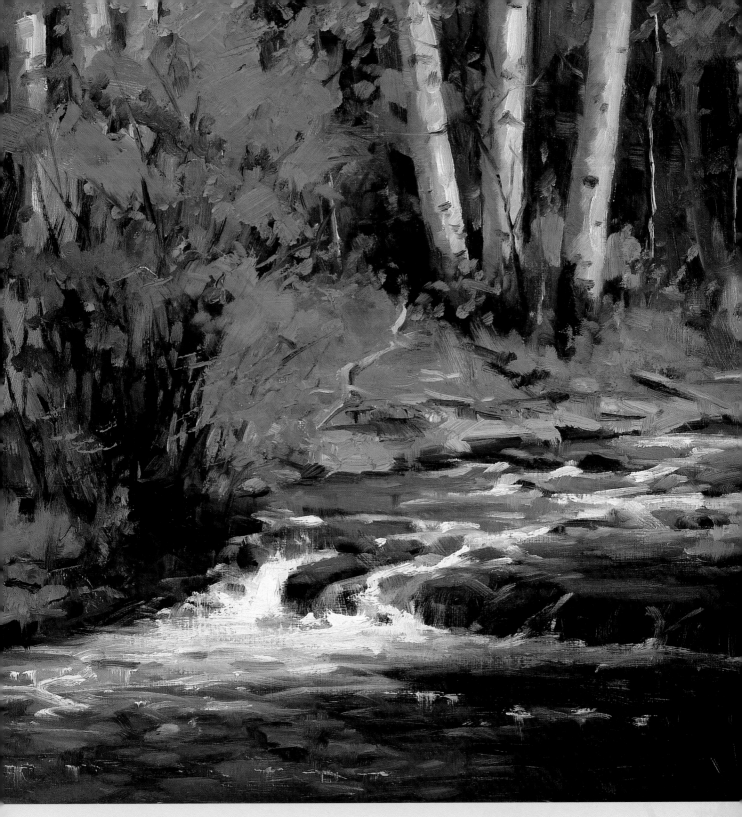

Limiting Earth Tones

This scene demonstrates the limitation of greens and color intensity when working with the earth-toned palette. In real life, the greens were very intense and vibrant. But the painting harmonizes, and all the hues relate well. It has a nice, quiet mood. If this is not the feeling you want to create, use a palette with more vibrant hues.

SUMMER FLOW
Oil on linen panel
14" × 14" (36cm × 36cm)

The Limited Palette with Grays

Adding a warm and a cool gray to a limited palette provides a greater degree of flexibility in mixing warm and cool hues of various values. You will end up with a painting of more subdued colors than you would with a simple limited palette. If you want such subdued colors, use primary colors made with modern pigments since they will stay more intense than mineral colors when mixed into the grays. Phthalo and Quinacridone colors hold up very well (although I prefer the more subdued hues produced by the less dramatic primaries).

Simple Primaries

This palette makes use of a simple group of primaries: Cadmium Yellow Light, Perylene Red and Ultramarine Blue. Added to these are Chromatic Black, Monochrome Cool and Monochrome Warm grays. You could easily mix these grays from the primaries and black before you start painting.

When mixing a warm midtone hue, use the Monochrome Warm; when mixing a cool midtone, use the Monochrome Cool. For clean color mixtures, use just the primary hues or primaries plus black.

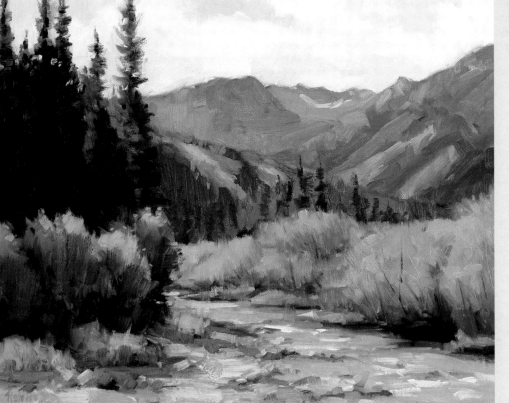

Surprising Palette

This painting shows that you can mix a full range of color, value and intensity with a limited palette. I don't think anyone looking at the painting would realize that it was done with three primary hues and grays.

FALL WILLOWS
Oil on linen panel
14" × 18" (36cm × 46cm)

Primary Intensity
You can still mix very vibrant hues while working with this palette because of the intensity of the three primary colors. The warm and cool grays are nice for mixing the more subtle hues of the snow.

EARLY FALL SNOW
Oil on linen panel
14" × 11" (36cm × 28cm)

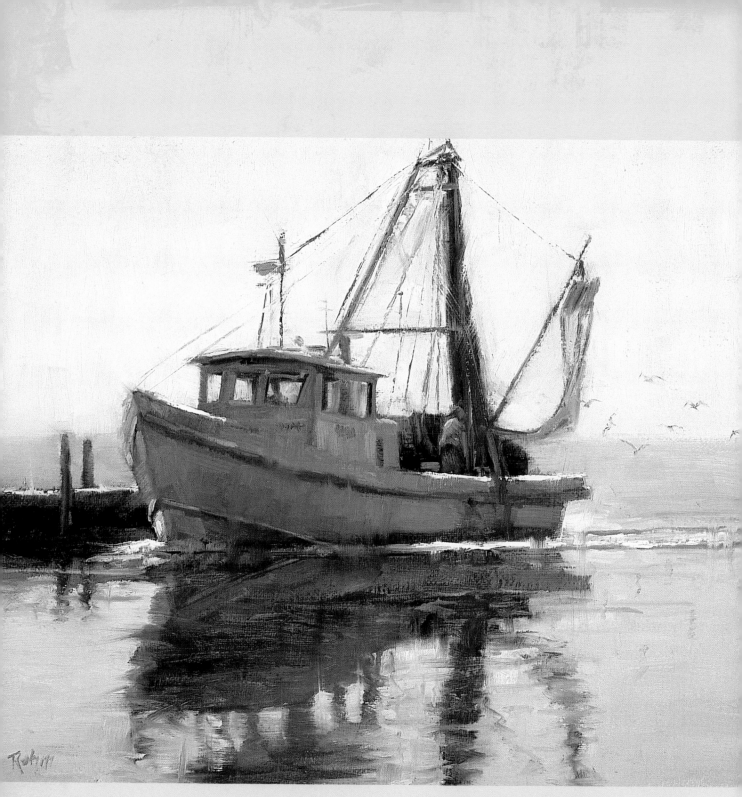

Gray Palette

The gray palette simplified the mixing process to achieve all the quiet hues in this painting. Try selecting a limited palette that aids in the look you are trying to achieve, but always make sure that red, blue and yellow are represented.

MORNING RETURN
Oil on linen panel
16" × 20" (41cm × 51cm)

Edge Control Is Crucial

Every stroke creates an edge. The skill comes from recognizing if the edges are good or need to somehow be modified. Edges give poetry to your strokes and can make them quiet transitions or dynamic focal points.

For a painterly painting, edge control is more important than the brushstrokes. You can apply a lot of beautiful brushstrokes, values and hues, but if the edges don't harmonize with these elements, the paint-ing will not work. You must also consider the edges between shapes and forms.

Edges can be hard, soft or moderate. *Hard edges* are dynamic divisions between areas; these are also called sharp edges. *Soft edges* are smooth, quiet transitions and are often referred to as lost edges. *Moderate edges* encompass all of the many variations between hard and soft edges. Dynamic edges com-mand attention, so step back often to evaluate what the edges in your work are doing in the composition. Too many obvious edges make a work busy. Too many soft ones make the work weak. You must orches-trate a poetic balance. This is a sub-jective creative choice on your part. Ask yourself if the edge of a stroke is calling attention to an area that should be quiet, and vice versa.

Thin Edges
To create sharp, thin edges, use the thin edge of the palette knife. You can also scratch into the wet paint with the tip of the knife or the end of the brush handle.

Another Method
Another method of making a thin line is to make a stroke and then paint over the edges on both sides until the line is the desired thickness. You can also vary the thickness and sharpness of the line as you paint into it.

Quiet edge, similar values

Softened edge, contrasting values

Transitional color

Hard edge, contrasting values

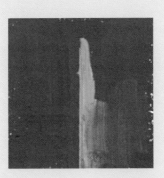

Edges with Palette Knives
When laying on areas of paint with a palette knife you can make only one good edge with the stroke. So, make the good edge where you want it, and then soften or paint back into the other edge to make it fit the painting.

Colors, Edges and Values
The top left example shows how two colors of similar value have a quiet edge between them. You would use this effect, for example, in a mass that you needed to keep similar in value while representing the warm and cool of sunlight and shadow.

The bottom right shows the dynamics of a hard edge with strong value contrast. The upper right sample shows how you could soften or lessen this hardness by simply blending the edge with a brush. Be care-ful, though—sometimes blending makes the painting dull and muddy looking. The bottom left demonstrates mixing a transitional color to soften the contrast. None of the edges are softened, but the transition color lessens the harshness of the hard edge. This is a great effect in painterly painting where the integrity of brushstrokes is important.

Transitional Edges

Another important characteristic of edges is their value. If the values of two strokes are far apart on the value scale, the edge will be dominant and appear sharp. Soften this effect by blending the two strokes together (the easy way out), or paint a stroke or two of transitional value between them. The latter technique is something not many beginner artists consider, but in painterly painting it is far better to save the integrity of your strokes by not blending them away. Adding a couple transitional color/value strokes not only enhances the brushwork, but also adds a painterly element of its own.

The closer together the color and value of two strokes or masses, the less obvious is the edge between them. Mary Cassatt used this very effectively when painting the soft-looking fleshtone of children. She exchanged warm and cool color for light and shadow effect, but changed value very little to create a soft feel to the form. These transitions don't work well when photographed in black and white but are amazing when viewed in color.

Orchestrating Edges

Atmosphere and distance create softer edges. Regardless of the con-

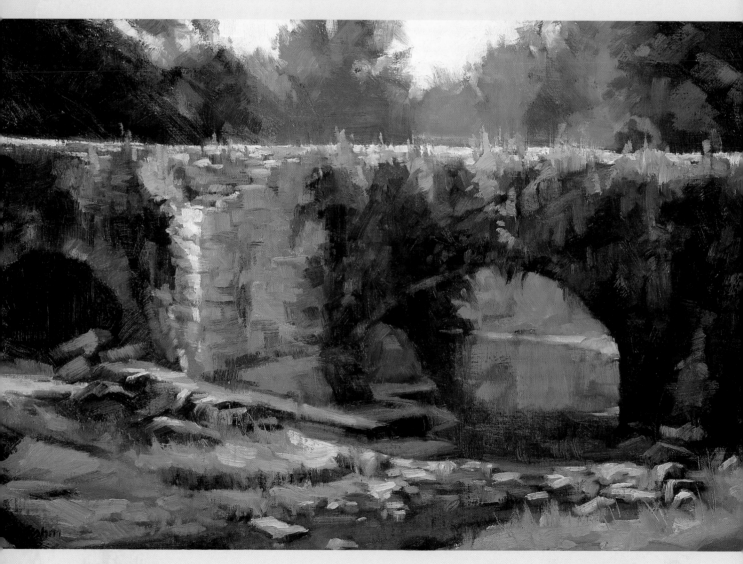

Integrating Edges
The orchestration of hard and soft edges, and of color and value, guide the viewer through the painting.
Let areas of your work be mysterious and quiet to emphasize what is most important.

SPANISH AQUEDUCT
Oil on linen panel
14" × 21" (36cm × 53cm)

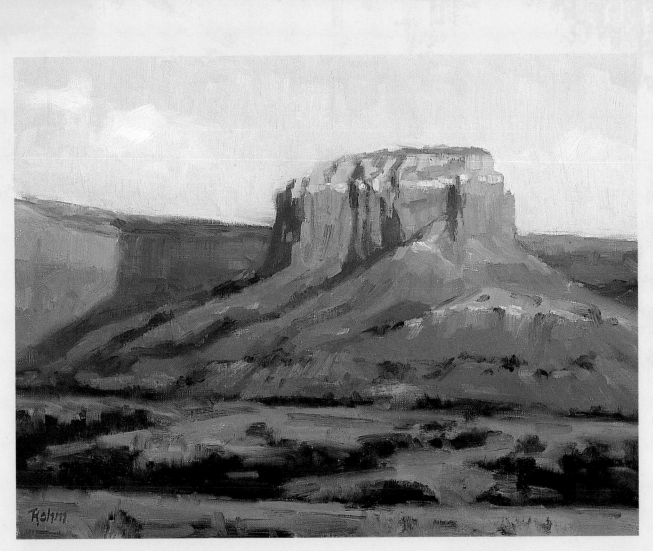

Light vs. Shadows
Keep your edges quiet and soft in the shadow and make them crisp and clean in the light around the center of interest.

STANDING PROUD
Oil on linen panel
11" × 14" (28cm × 36cm)

trast in the distance, the edge will be soft compared to the middle and foreground and needs to be painted that way to communicate depth in a painting. Sharpening an edge in the distance flattens the visual space so that it looks more abstract, emphasizing the two-dimensional qualities of the surface. If this is your goal, go for it, but if you are trying to represent natural space, watch that those edges don't get too sharp.

Round forms turn away from the viewer. Clouds in the sky have soft edges. Keep the edges soft even when portraying a dynamic sunlit cloud against a deep blue sky.

Moving water and fields of grasses in the wind will look stark and unrealistic if they are painted with sharp edges and will break up the simplicity of the mass. A moderate choice is best here since a very soft edge will look like blurred motion in a photograph taken with a long exposure time.

Squint to see the edges in your scene, and then be selective to control the visual flow. By all means, don't paint the edges that you don't see just because you know where the edge of something is. If you don't see it, don't paint it.

The eye is always drawn to contrasts of hard and soft edges as well as of color and value. Use this fact as a visual tool to create a poetic painting, and don't be a slave to the scene's content.

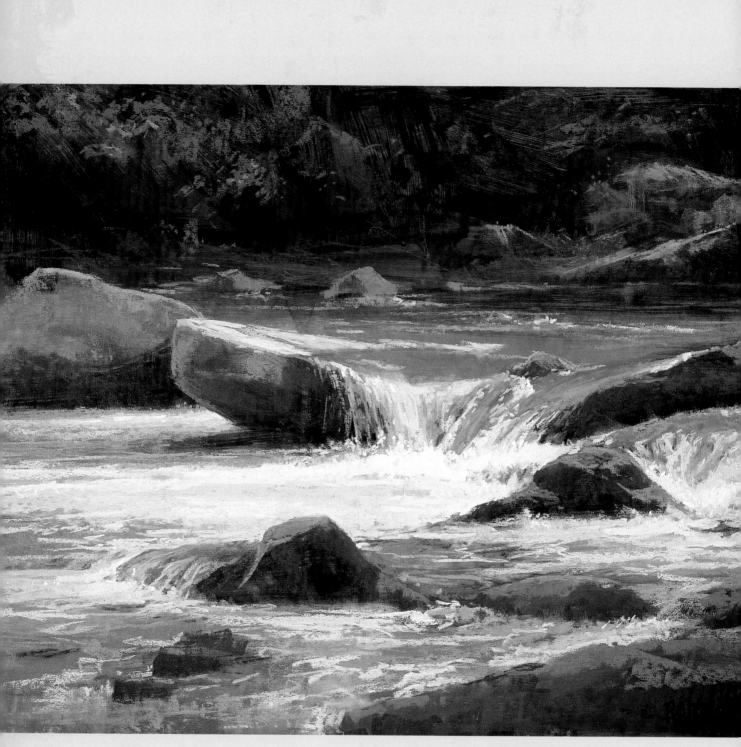

Edges in Creeks

A river or creek bed makes an excellent scene for practicing edges. Water needs to flow, but can't be too soft-edged. The rocks need soft-edged form but have distinct edges separating them from other objects. The background needs to be suggestive of trees, bushes and rocks, but the edges should not compete with the more important elements of the scene.

RIVER ROCK
Pastel on sanded paper
18" × 24" (46cm × 61cm)

Capturing Mood

If you simply copy a scene from the source, you risk creating a visually boring painting. You may succeed in capturing the color and value with a good composition, but where is the character? Do you merely want to record what you see, or are you creating a work with emotion?

When I go into the field, most of my en plein air work is focused on capturing the relationships of the scene. How dark or light, warm or cool, dull or vibrant is one element compared to another? For a field study this is plenty to consider. However, there are times when I am inspired by the *mood* of a scene. This elusive emotional quality can be the most difficult to capture, due to the rapidly changing light and the natural elements of a landscape, or the mechanical coolness of a model or still life in a studio situation.

To capture mood effectively, all of the elements of color, value, composition and edges must work together. You may want a scene bright and cheerful, or dark and somber, or somewhere in between.

When you go beyond simply recording the relationships of elements in a scene, you may ignore certain value and color changes to emphasize the feeling you are after. The low, high and middle key value plans are important tools in doing this. Choosing to work in a dramatic low key, for example, may require that you ignore the brilliant light on the field to emphasize the contrast between trees and sky. Ask yourself, "What is the most important thing about this scene to me?"

Your brushwork is also important to the mood you are trying to create. For instance, hard-edged, dynamic strokes of thick paint would not be appropriate for a peaceful scene.

Capturing the mood of a dark or cloudy scene, or a fleeting stroke of light on a distant mountain, is a challenge. Look for that dramatic moment and freeze it in your memory, then use what is in front of you for reference only. Don't start copying what's out there or you will lose the idea that attracted you.

For the most part, creating a mood requires that you minimize the dynamics of most of the scene to emphasize the drama in a particular area. It takes recording a scene to another level of thought. Before you start, ask yourself if you are recording the relationship of elements in this scene, or is there a feeling about this time and place that you want to capture and communicate in the finished picture. Decide on this before you start painting. This will give your choices for value, color and edges purpose and meaning.

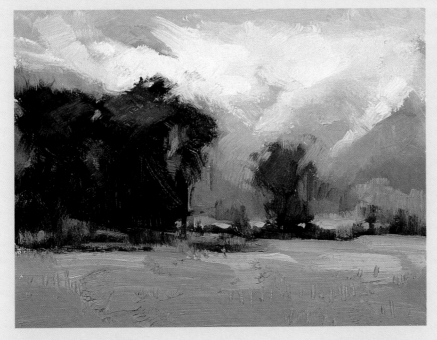

Limited Palette with Grays

This study captures the effect of low rain clouds on the distant mountains. The grayness of the color contributes to the quiet, somber mood of the approaching rain. Bright, clean colors would create the sense of sunlight and therefore would not fit the intended mood of this scene.

THE MOOD OF RAIN
Oil on linen panel
6" × 8" (15cm × 20cm)

STAY TRUE TO YOUR ORIGINAL IDEA

An effective way to approach a moody situation is to take a large brush or a big pastel stick and very simply lay in the dynamics of your scene. Too often we lose this idea as we get caught up in the painting of other elements. So, as you begin to embellish the shapes, don't lose the idea by adding too many colors, values or textures. Always keep an eye toward your beginning idea, and adjust what you add to fit the mood you were seeking.

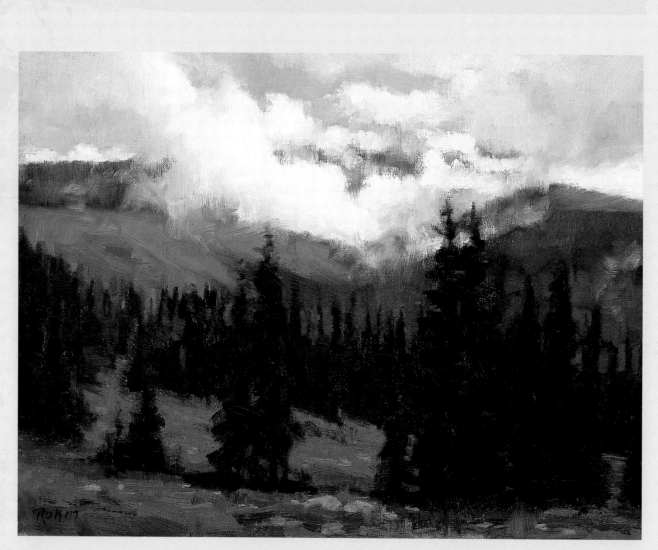

Bringing It All Together

This is a low-key painting with a large dark area and a small light area. The mood is quiet and thoughtful. The only bright color and value is used in the center of interest area to give it a positive emotional feel. The somber, dark gray hues of the majority of the painting are used to dramatize the pleasant feeling of the rain clouds clearing.

CLEARING
Oil on linen panel
12" × 16" (30cm × 41cm)

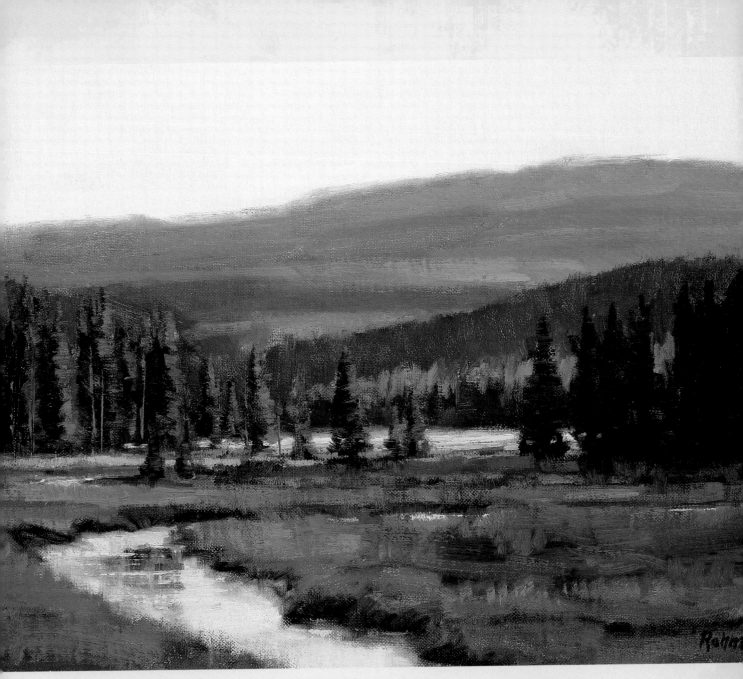

Temperature Contrasts

The mood in this work is produced mostly by the contrast of warm and cool colors. None of the colors are particularly intense, so it is mostly a play of value and color temperature contrasts.

AFTERNOON SHADOWS
Oil on linen panel
12" × 16" (30cm × 41cm)

CREATING MOOD

Consider all of the elements of a scene when creating a mood. Constantly ask yourself during the painting process if what you are doing with composition, value, color and edges helps or hurts the mood you are trying to depict in this work.

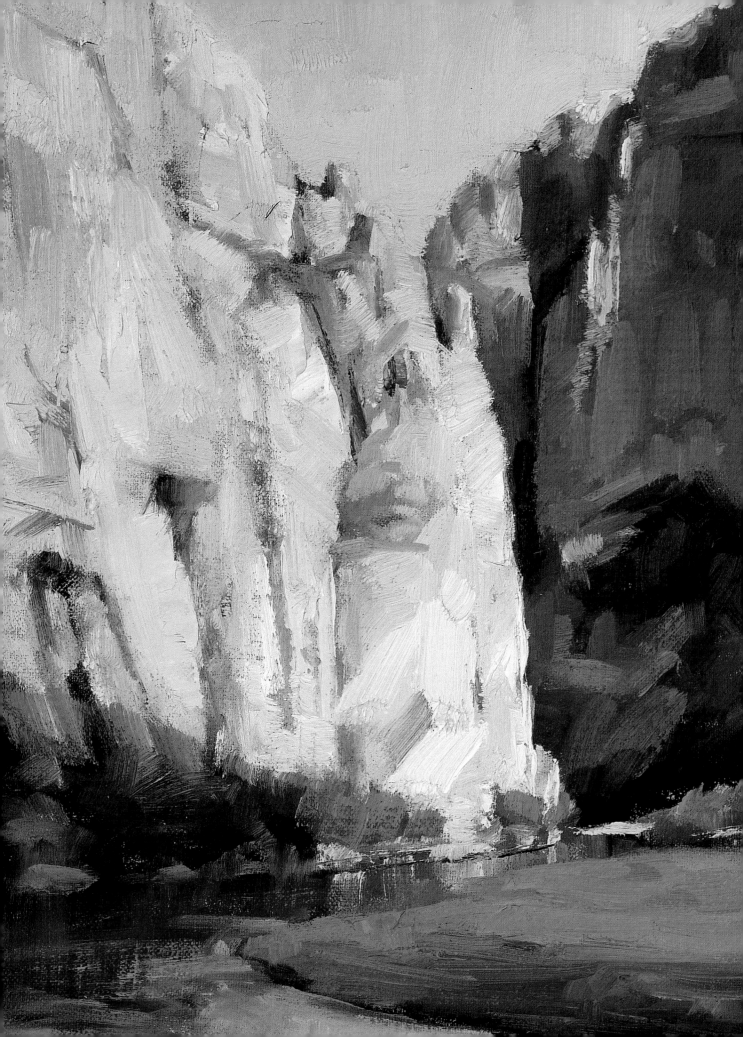

4

The Painterly Process

The method we use to construct a painting determines our success in executing our ideas. Method is an acquired skill, wherein we bring together the fundamentals to achieve our goal of how we want to paint, and how we want our work to look. Remember, technique produces the end result.

For me, the painterly approach is more about the relationships of color, value, composition, texture and mood than it is about the subject being painted. It's a process by which we interpret and express an idea or feeling rather than render a particular subject.

BOQUILLAS CANYON
Oil on linen panel
12" × 8" (30cm × 20cm)

The Painterly Working Method

Artists use many approaches to create their work. Most are a variation of either the linear drawing approach or the painterly mass approach. Regardless of how you work, you can finish a picture in a poetic and painterly manner by suggesting detail where such information is important to convey the subject, and by loosely suggesting or eliminating it where it is not.

For many *alla prima* (paint in one sitting) artists, the painterly approach is the most natural way to express their interpretation of a scene. The painterly approach expresses the relationship of the main masses rather than draws the detail of a subject. Many artists are so focused on the subject and on getting the contours and textures of it "correct" that their work feels stiff and overdone. Using a painterly approach, the artist tends to dwell less on the details of the subject and more on the poetic qualities of shapes, edges, values, colors and the mood of the picture.

The painterly approach I use is very traditional because I work:
- Dark to light
- Thin to thick
- Transparent to opaque

Watercolor utilizes the reverse of these approaches since you save the lights and build the middle and dark hues. For this reason, we will not discuss watercolor, though it can also be used as a painterly medium.

The concepts for painting with oil, pastels and acrylics are the same except for variations in how the mediums are handled. This makes working interchangeably among them easy. Each can be handled differently, but I approach them all in the same painterly way.

Although I do not believe in formulas for painting, there are a number of concepts to consider as you develop a painterly working method. These concepts are intended to trigger your thoughts and imagination:

1. **Formulate the idea.** What is your idea for this picture? What do you want the viewer to see? Try to have a concept before you begin. It may change as you paint, and that's OK, but you need a starting point.
2. **Simplify the shapes.** Try to see the picture as no more than six to eight major shapes. Look for opportunities to link values or color masses together to make one shape where there may have been three or four.
3. **Average the values.** Try to organize your subject into masses of four values, five at the most. Determine what averages are the darkest, dark-middle, light-middle and lightest value masses.
4. **Average the color.** Simplify each value mass into an analogous color shape. Determine the dominant hue of each mass and if the color is warm or cool. Often, a mass is defined by color temperature even though the values of the two areas are the same. It is very common to find a light, warm-toned field the same value as the cool sky.

 At this point, your underpainting will be done. You have the concept, a design of masses, the value key and color harmony. Work loosely with very little paint or pastel buildup. This makes adding layers of pigment and pushing and pulling the edges of masses simple.
5. **Determine the extremes.** What is the darkest dark, the lightest light, the most intense hue and the most dynamic edge? You don't need to paint each of these completely; just make sure that each is accurately represented.

PRACTICE WITH SMALL STUDIES

Try to limit yourself to a 1/2-inch (12mm) brush on a 6"× 8" (15cm × 20cm) panel with only three primary colors plus white. You will learn the essentials of values for large, medium and small shapes; intensity; warm and cool color effects; and the importance of edges in defining objects. Limit the time spent on each of these studies to thirty minutes or less. This can be done as a warm-up for each painting session, or an entire day can be spent on location doing nothing but these studies. Nothing will teach you more or give you more confidence to handle any subject than doing lots of these simple studies.

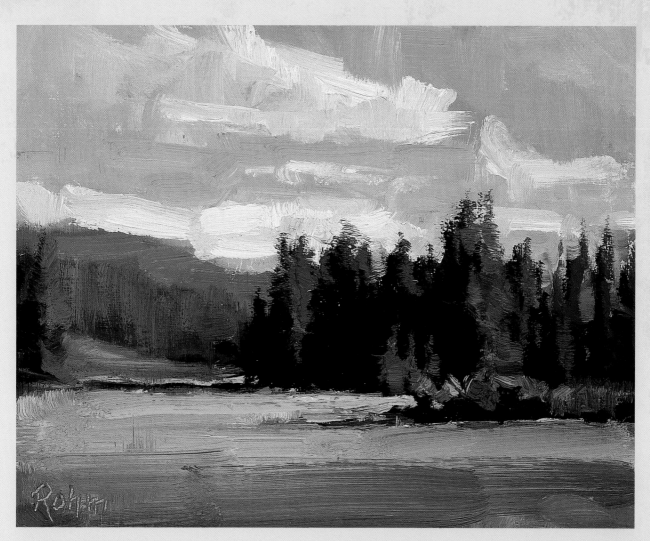

The Painterly Approach

I made this quick study with nos. 6 and 8 flats and a 1-inch (25mm) painting knife. The palette included Cadmium Yellow Light, Permanent Alizarin, Ultramarine Deep Blue, Viridian and Titanium White.

By focusing on the masses, you can relate the qualities of design, value, color and edges to express the dynamics of a scene rather than describe the details of its content. Thus, the painterly approach is about the relationships of the elements.

AFTERNOON LIGHT
Oil on linen panel
6"× 8" (15cm × 20cm)

With the extremes added to the underpainting, you've solved this picture. Now you can concentrate on how much you want to modify the masses and how much color variety, texture and information you want to suggest. Always make these modifications in relation to the extremes that you established. Nothing you add should be darker, lighter, more intense or more dynamic than your established extremes. If any of the important relationships of the underpainting are imbalanced, such as the color or value of one of the masses, adjust it now before refining the picture further so that the relationships are relatively correct.

You can develop the work from this point, keeping it simple and very abstract, or carry it to a very realistic finish over several painting sessions. The key is to make progressively more descriptive strokes that suggest the relationships without drawing objects. Paint shapes and relationships—not things. The more experienced painterly painter recognizes that the early work in these areas is more spontaneous in both color and gesture than later layers, and will allow this to guide the development of the work and show through the layers in the finished painting.

Painterly Studio Work

I value the expressive and poetic nature of the painterly approach, but there's a very logical process you can follow to speed the process of painting by establishing the correct relationships of the masses early in the painting. By establishing these relationships early, you are less likely to need dramatic changes later in the process, and you'll have a better focus on where you're headed with each painting. This speed is essential when working outdoors under changing conditions, though the process is basically the same for large studio works.

Materials

OIL PALETTE
Titanium-Zinc White • Cadmium Yellow Light • Yellow Ochre • Burnt Sienna • Cadmium Orange • Permanent Alizarin Crimson • Ultramarine Deep Blue • Viridian

BRUSHES
Nos. 6 and 8 hog bristle filberts • no. 2 hog bristle extra long filbert

SURFACE
Oil-primed linen panel

OTHER
1-inch (25mm) painting knife • marking pens in 20%, 40%, 60% and 80% gray • mineral spirits

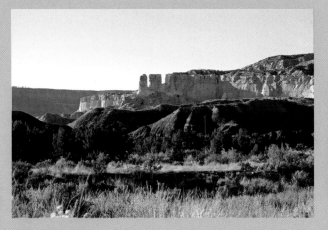

Reference Photo

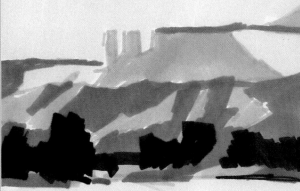

Value Sketch

This simple value study was done with four marking pens (20%, 40%, 60% and 80% gray). I always save the white of the paper and use a black pen for accents if needed.

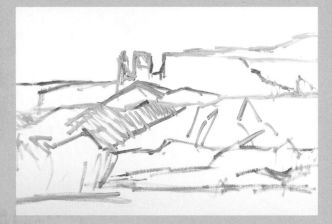

1 Find the Basic Structure with Warm Tones
Find the basic structure of the scene and simplify the shapes as much as you can. Use mineral spirits to thin a warm tone of Burnt Sienna for sketching. I almost always start with warm hues, as they are well-suited to the landscape and blend nicely into the scene. I have used cool hues, but they tend to gray and muddy additional layers of color.

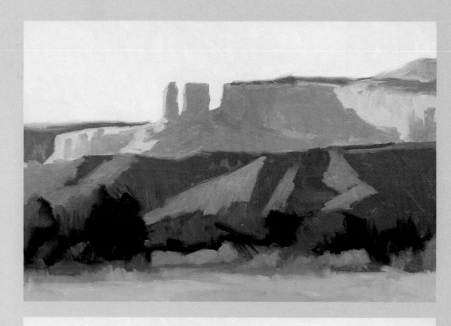

2 Fill in the Major Shapes
Fill in the major shapes with the average color and value for each mass. Start with the darkest hues to keep them clean and free of white paint. Thin the color washes with mineral spirits or a medium, but don't make them too wet, or it will be difficult to add layers of color when working wet-into-wet. Use just enough to make the paint easy to spread.

Some shapes of similar value may be separated by warm and cool hues, as in the shadow mass of the cliff. The upright plain has warm reflected light, while the slanted part reflects the cool blues of the sky. Together these form one mass of light-middle value. The values are not restricted to light or shadow. Here the middle-light value shape of the shadow on the upright cliff is the same value as the sunlit area of the slanted hills in the middle ground.

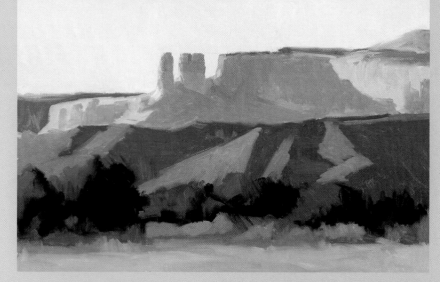

3 Establish the Extremes
After the masses are filled in with their average color and value, establish the extremes. Identify the darkest dark, the lightest light, the most intense color and the sharpest or most dynamic edge. It's not necessary to complete these areas, just establish them.

You now have the structure needed to paint the scene. Nothing will be lighter or darker, more intense or sharper-edged than these extremes. You also have the value relationship, color harmony and composition for the painting. Next, modify the masses and suggest form and detail, but be careful not to clutter these masses with too many colors and value changes.

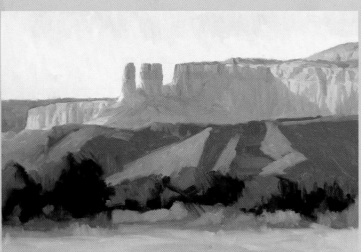

4 **Continue Developing the Painting**
With the extremes in place and the masses correctly established, you can now develop the painting.

Paint the sky, since you know exactly how light to make it compared to the light on the chimney rock. Then begin modifying the shadow shape of the cliff, adding the suggestions of color variations, textures and forms while maintaining the value integrity of the mass.

5 **Work Wet-Into-Wet with Subtle Value Shifts**
Work the paint together wet-into-wet on the surface. Do not over mix the warm and cool hues; this will create mud. Notice how close the values are. Very slight value shifts are all it takes to show form.

The edge of light on the front of the chimney rocks is the most dynamic edge in the painting. Contrast this unusual shape with the warm hues against the cool of the sky and shadows to make this area important. It would have been easier to lessen the dynamics of this area and sharpen an edge and contrast in the foreground to change the center of interest, but this makes for a far more interesting painting.

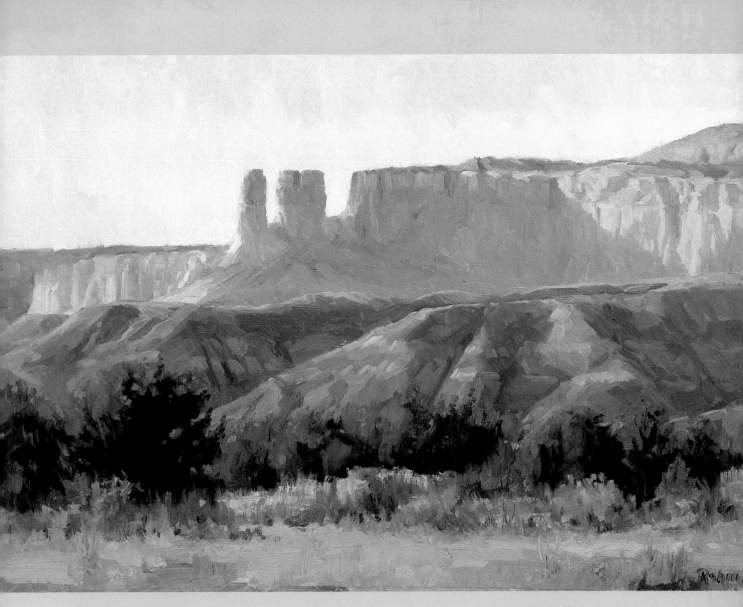

6 Complete the Painting

As you modify the masses, relate to the extremes so that you don't compete with what is most important.

It's unusual to have the most intense color in the distance without flattening the space. To flatten the space, keep the yellow-greens in the foreground fully saturated and be sure not to wash them out with white paint. The value range of the saturated yellow-greens and strong darks comes forward and allows the close-value cliffs to appear distant in spite of their strong color.

It's also important to watch the edges as you add more value range and more saturated hues to the foreground. By being mindful of your edges, you'll avoid creating an edge contrast that would compete with the chimney rocks in the distance.

Apply thick paint to the foreground to add texture; the background cliffs, especially those in shadow, should have very little texture.

CLIFF SHADOWS
Oil on linen panel
20" × 30" (51cm × 76cm)

Painterly Location Work

My approach to painting on location is the same as for the studio; however, on location I am more concerned with studying the correct relationships of masses than with producing a gallery-ready painting. If I do get gallery work, great, but that is never the goal. It took years of practice to allow myself to think this way because we all naturally want every work to be a masterpiece.

In this demonstration you can see how following a logical approach is a fast and accurate way to capture the dynamics of a scene. By quickly establishing the average color and value masses and the extremes, you are better able to handle changing conditions such as sunlight and clouds. Once you have developed this underpainting it is your road map so that even as conditions change you know the direction you want to go.

Materials

OIL PALETTE
Titanium-Zinc White • Cadmium Yellow Light • Brunt Sienna • Cadmium Orange • Permanent Alizarin Crimson • Ultramarine Deep Blue • Viridian

BRUSHES
Nos. 6 and 8 hog bristle filberts • no. 2 hog bristle extra long filbert

SURFACE
Oil-primed linen panel

OTHER
1-inch (25mm) painting knife • mineral spirits

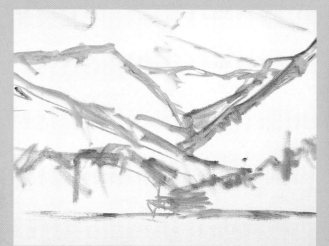

1 Draw the Basic Structure
Begin by finding the simple organization of shapes.

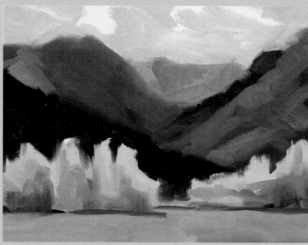

2 Fill in the Average Color and Value
Fill in the average color and value for each shape. Keep the paint thin, but not too wet. The wetter the underpainting, the harder it will be to add layers of color wet-into-wet in one session.

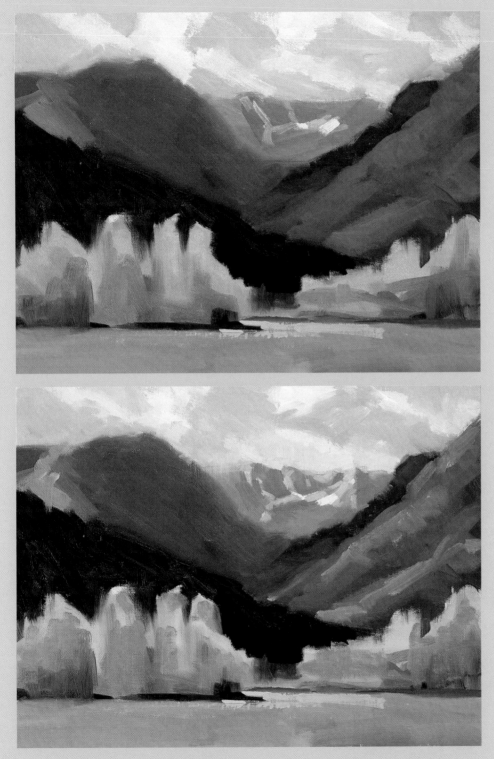

3 **Find the Extremes**
Establish the extremes of color, value and edge: the darkest dark, the lightest light, the most intense color and the dominant edge. At this point in the design, you still have options for the center of interest. You could make it the distant mountain or the yellow trees in the field.

4 **Develop the Sky and Distant Mountains**
With the design, color and value pattern established, use the extremes as points of comparison. I began to develop the sky and distant mountains because I wanted to establish the relationship between them early in the painting process.

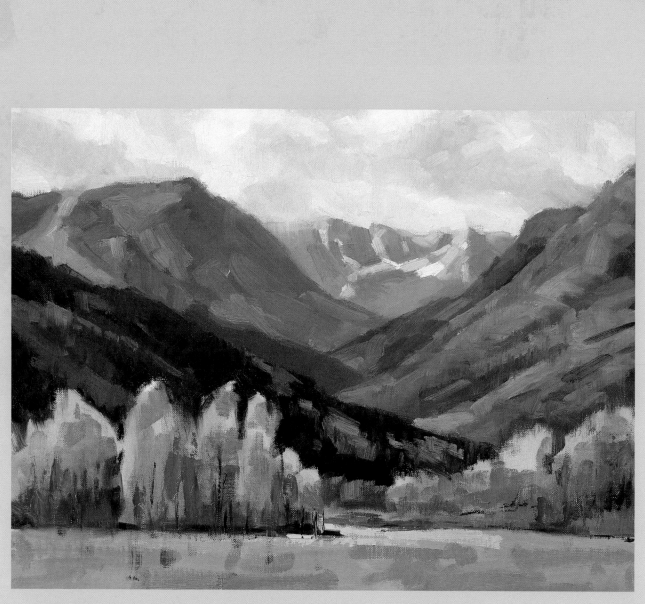

5 **Distinguish Textures and Values**
As the painting nears completion, concentrate on the texture and values of the trees and field compared to the background mountains. Remember: Thick paint, hard edges, strong color, value contrasts and vigorous brushwork come forward while soft edges and cool, thin color recede.

KNOW YOUR MEDIUM
Expression and suggestion in painting directly reflect the artist's command of technique and understanding of the medium.

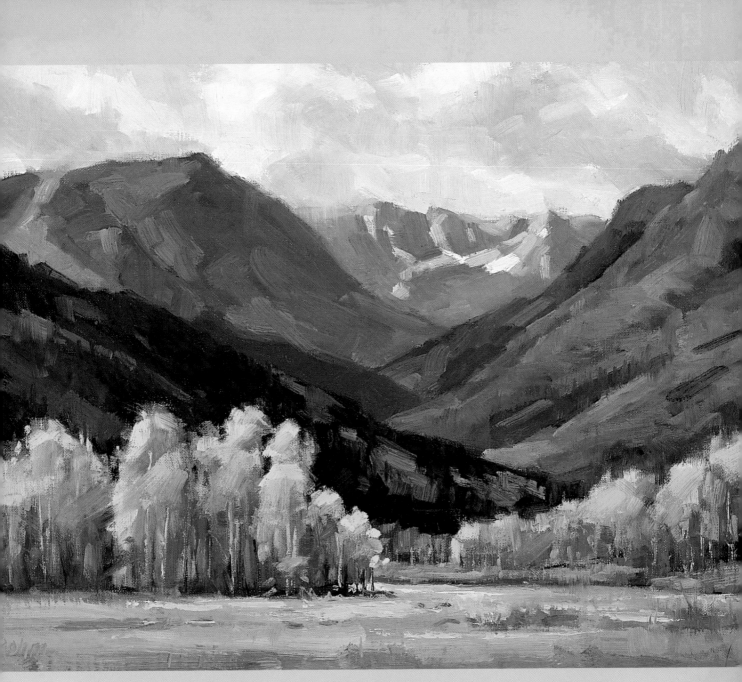

6 Add the Finishing Touches

I chose to make the light yellow trees against the dark mountain the center of interest for the design. To me, this painting is about the space—the subtle dynamic of the distant mountain with snow and sky compared to the brilliant fall colors in the front.

It would be easy to create too many value and color changes in the mountains and clouds, making the scene busy. It is very important in a scene like this to keep the shapes close to the simplicity of the basic structure while suggesting color changes and textures.

The way a work is constructed shows how a painter interprets the subject. Allowing background colors to show through adds depth and spontaneity to the painting.

FALL COLORS
Oil on linen panel
12" × 16" (30cm × 41cm)

Building Painterly Layers

Pastels are a fun and challenging medium to work with. You can use them in a thin, linear fashion as a drawing medium, or you can paint with them by building layers of color with various grades of pastel. Pastels are well suited to a painterly approach because of their gestural quality.

Since with pastels you can only mix color optically in layers, you need to have a lot of pastels on hand to achieve the various hues and value choices needed for painting. That said, I am always surprised to see how few pastels it takes to complete a painting. The key is knowing in advance exactly which colors, values and grades are needed, so be thoughtful in assembling your working set.

My working set includes a full range of hues covering the primary and secondary colors in no fewer than four values. It's important to have the grayed tones of these colors and only a select few very intense hues. I organize them in hard grades mostly for underpainting, middle grades for the majority of the painting and very soft grades for accents and thick opaque strokes.

Unwrap your pastels and break them into approximately 1-inch (25mm) sticks. This will allow the greatest flexibility for making a variety of strokes from the broad side to the tip.

Materials

PASTELS
A large selection of hard pastels • A full range of hues and values in medium and soft pastels

SURFACE
Light, neutral, sanded pastel paper mounted on board

OTHER
Stiff bristle brush • water or mineral spirits

DRAWING OR PAINTING?
A pastel drawing allows a majority of the surface tone to show. When most of the surface is covered with layers of pastel hues, it is considered painting.

Pastel Value Groups
I selected these hard pastels in four value groups. Each group is the average color and value for the main shapes of the scene. Notice that the light-middle value group has both blue for the sky and pink for the earth. These areas are very different in color temperature, but are similar in value.

Pastels for Subtle Layering
Here are the soft pastels I used for this painting. The red was the most dynamic hue in this scene and had the most variety. However, most of the pastels used were gray and mixed with other colors. This allows for subtle layering, which is an important part of the painterly approach.

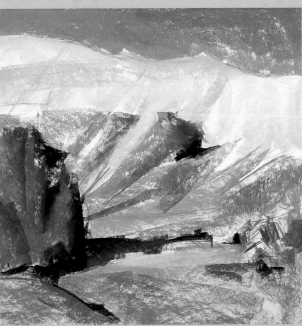

1 Block in the Basic Shapes and Directional Flow

Starting with a piece of sanded pastel paper mounted on board, locate the main shapes and directional flow of the scene with a warm-toned hard pastel. Using a light, neutral paper allows you better control of the color harmony.

2 Fill in the Main Masses with Four Values

Mostly using the flat side of the hard pastels, lay down a thin layer of color for each of the main masses. Do this by averaging the masses into four value groups. Although you can see more values than that, four will give you a good, clean structure to paint over. If you use more than that, the scene will lose its structure and become too busy.

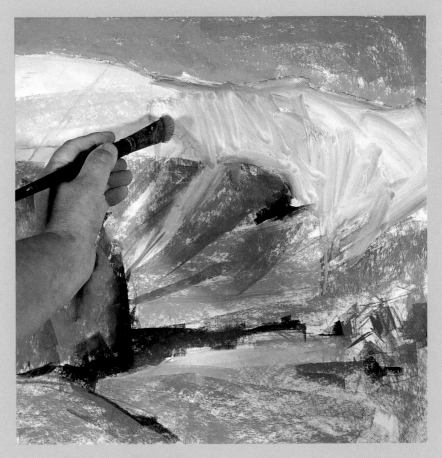

3 Scrub to Create a Solid Layer

Using a stiff bristle brush and water or mineral spirits, scrub the hard pastel into the sanded paper. This tones the paper in the value and color chosen for each of the main shapes, and the layers of color that will show through in the finish will be appropriate for the mass (unlike the spot of white or color you would get working on a toned surface). This way you won't have unwanted color showing through your layers of pastel.

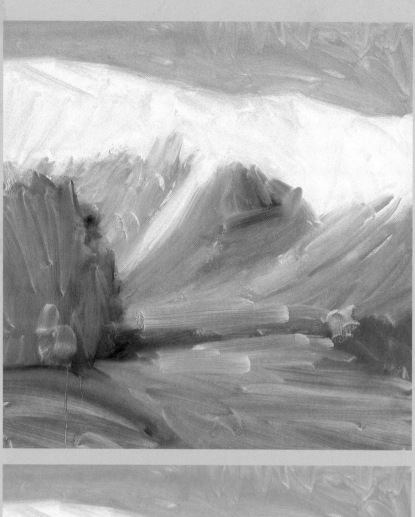

4 Create Soft Edges

Softly blend the shapes from one to another so that as the painting develops, the edges of shapes can be pushed and pulled with ease. If you create hard edges or leave paper showing around the shapes, they can be problematic when you refine the painting.

This soft-edged toning serves many purposes. It shows you the color harmony and value pattern of the scene as well as the design. If there's a part you don't like, it's easy to change and re-tone at this stage since there is very little pastel on top of the surface.

Sometimes I achieve this result using water, mineral spirits and alcohol, or by simply rubbing in the hard pastel with a cloth. Each method works and produces a different look. After time you will choose the method that best suits the scene or your preferred style.

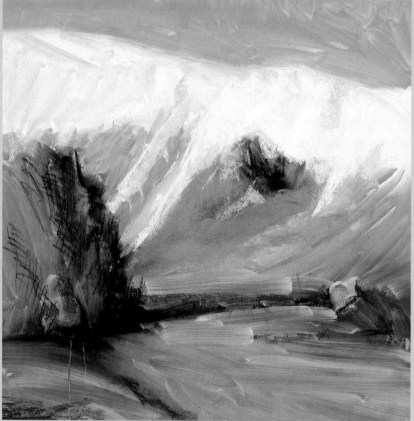

5 Reestablish the Darks and Establish the Extremes

Reestablish the darks, following the wash and toning of the scene. Many times they are overly softened in the previous steps. Identify the darkest dark, the lightest light, the most intense color and the sharpest edge.

With this undertone and the addition of the extremes, you have a complete road map for the painting. It will be easy to modify hues, values and colors as you add layers of color.

This working method is very painterly because very few areas are critically defined. All the areas are suggested and have a wonderful, expressive quality. Working in this manner, you will be surprised how much of the finished work can be left as is by concentrating on developing the areas that are most important to defining your interpretation of the scene. This approach works equally well for figure and still-life works.

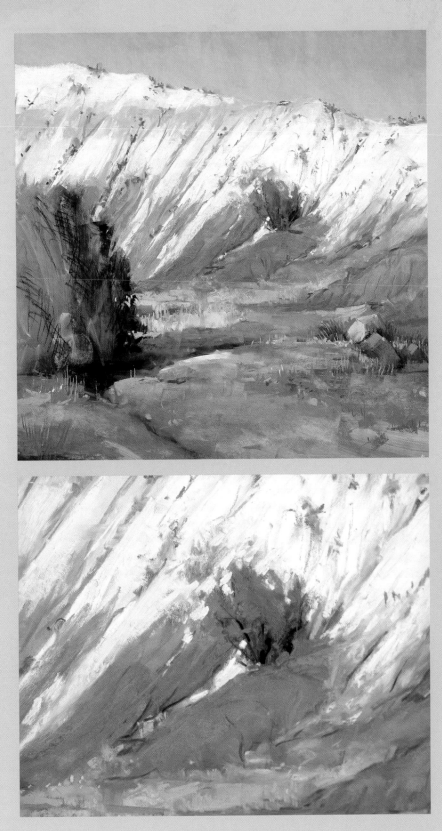

6 Add More Layers of Color and Texture

From a design standpoint, the painting is fully resolved at this point. However, several areas are only the undertone, so add more layers of pastel to them. Remember, if the relationship of the elements works, then how much color and texture you add to the painting is your choice. Be careful not to make strokes and hues that distract from the balance of the picture.

7 Play Up Light and Color Contrasts with Painterly Strokes

This detail shows the dynamic contrast of value and color around the bush, which is the center of interest. Play up the sharp contrasts of thin darks and thick, opaque lights in the light of the ground, the dark branches of the bush, and the color contrast of the blue shadow and the orange of the sunlit earth. This combination of elements aren't found anywhere else in the painting.

Notice how suggestive pastel these strokes are. None of the elements are exactly rendered; they are suggested with expressive marks. This is the painterly approach.

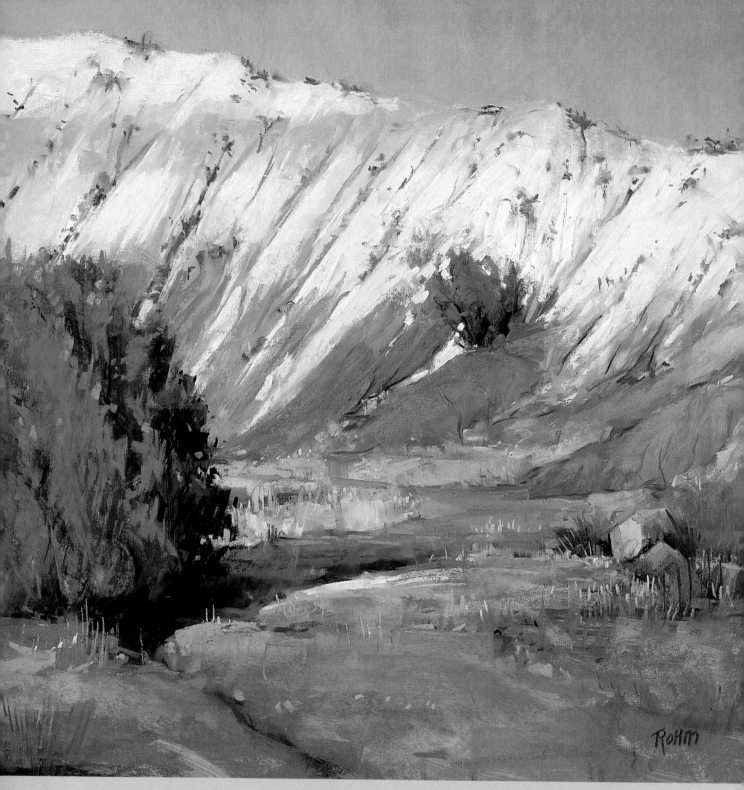

8 Finish, But Don't Overdo It

At this time you can feel comfortable calling the picture done. Adding more would be less suggestive and painterly and may make the painting busy with strokes and edges that don't enhance your impressions of the scene. I'm pleased with the dynamics of the picture, such as the vibrancy of the strong red-orange compared to the softer hues in the rest of the scene. While the reds are unnaturally intense, this is the expressive idea that I had for the picture. It works because the painting's other hues enhance the red and don't compete with it.

O'KEEFFE COUNTRY
Pastel on sanded paper
18" × 18" (46cm × 46cm)

Luminous Color

Painterly pastel painting uses the application of the overall masses of color with the addition of layers of color. The color should not be blended by rubbing with fingers or a stump as this would reduce its luminosity. As an opaque medium, subsequent layers are applied using a "soft touch." The more you paint with pastel, the more you will learn the touch required for each brand as it is used to build layers.

Materials

PASTELS
A large selection of hard pastels • A full range of hues and values in medium and soft pastels

SURFACE
Warm-gray sanded pastel paper

OTHER
Soft cloth • water or mineral spirits

Pastel Value Groups
These four value groups of hard pastels are used for the early stages of this picture. The dark-middle value of the shadowed cliff and water are the largest shapes; far more color variations for them are selected than for the other masses. This provides a lot of color variation and interest. In less important masses, use one or two hues of the same value.

1 Locate the Thirds and Draw the Basic Shapes
Divide the sanded pastel paper into thirds, then begin drawing in the main shapes.

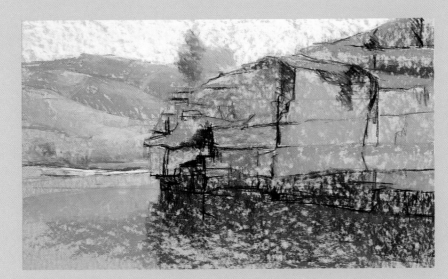

2 Create the Average Color Reference
Using hard pastels to keep the layer thin, lay down some average color reference for where you want to take the painting. Because of the intense yellow reflections in the water, you can use many warm tones in the cliff and they will still work as a shadow plane, since they are cooler and less intense next to the yellow in the water.

3 **Use a Cloth to Soften the First Layer**
Rub in the hard pastel undertones rather than using a liquid solvent or water. This will let the paper color show through the finished painting (whereas the liquids would more fully cover the paper's tone). Here, paper becomes the unifying color harmony of the painting.

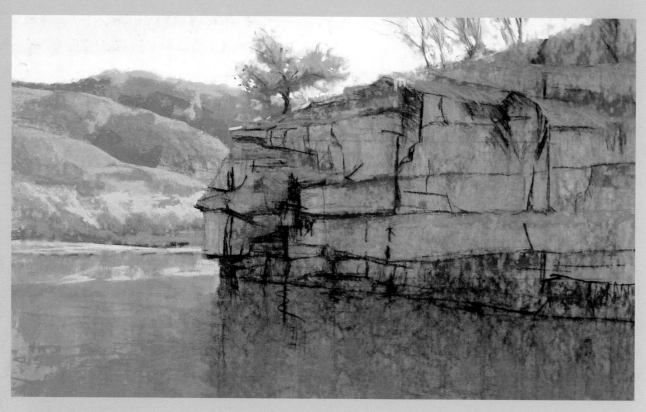

4 **Establish the Extremes**
Establish the lightest light, the darkest dark and the most dynamic edge, and begin to define the darks. Use hard pastel in the dark areas to keep them thin, then set them aside to paint with medium and soft pastels for the rest of the scene. You may need to use one or two hard pastels to create accents.

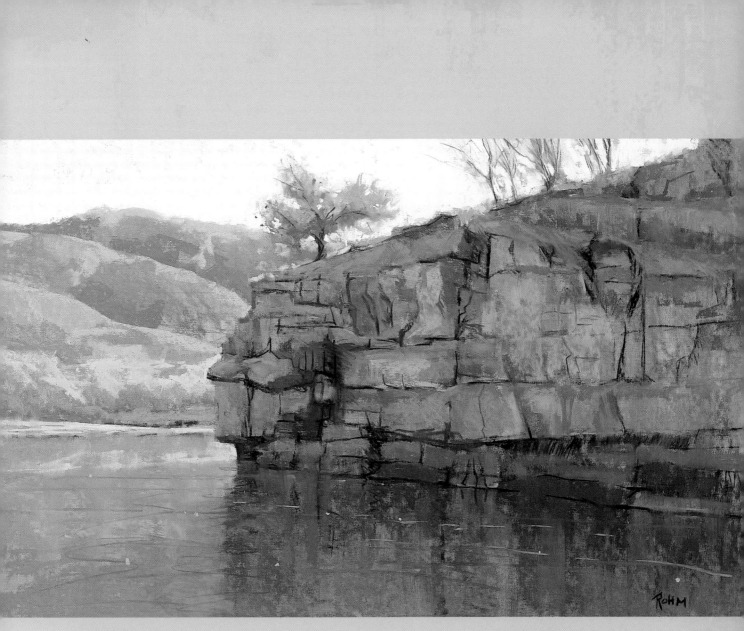

5 Finish the Work
Notice how much of the paper color still shows in the finished picture. The yellow trees are the most intense color but they stay in the distance because of the limited suggested form. Compare that to the shadowed cliff, which has a lot of suggested detail. This is accomplished with edges and value contrasts.

Early layers of color must be allowed to show through in places so that, as pastel is added, a feeling of depth and atmosphere is created and adds to the painterly feeling of the work.

SHADOW LIGHT
Pastel on sanded paper
15" × 24" (38cm × 61cm)

USING TONED PAPER

I choose a toned paper for how well it suits the picture. Otherwise, I use a white sheet and selectively tone it for the main shapes in the underpainting stage. In this painting, the warm tone and middle value of the paper is ideal for all the earth tones in the scene.

Layering Transparent Color

Acrylics don't hold brushstrokes and texture as well as oils, and the surface can become flat and boring, so build a slightly aggressive surface by priming the surface with several layers of gesso. When combined with transparent layers of color, a little palette knife work and the textured painting surface, the results achieved with this medium can be very satisfying.

My goal here was to capture the warm glow of the late afternoon and the dramatic warm light on the limestone cliff contrasted by the dark foliage.

ACRYLIC TOOLS

Plastic knives are better suited to acrylics. Since the brushes stand in water a lot of the time, traditional oil painting bristle brushes swell and lose their shape. Use inexpensive, student-grade bristle brushes to prevent ruining your good oil brushes. Their flexibility and shape when swollen with water is perfect for painting with the transparent, watery acrylics. They create ragged dry-brush edges. If you need more control, use a synthetic bristle brush, which won't be affected by the water.

Materials

ACRYLIC PALETTE

Cadmium Yellow Light • Yellow Ochre • Cadmium Yellow Medium • Cadmium Orange • Burnt Sienna • Quinacridone Red Light • Quinacridone Red • Quinacridone Crimson • Ultramarine Violet • Cobalt Blue • Chromium Oxide Green • Permanent Green Light • Titanium White

BRUSHES

Six or more inexpensive hog bristle brushes ranging from no. 2 to no. 16 • no. 6 synthetic flat • no. 2 synthetic round

SURFACE

Cotton canvas primed with several layers of acrylic gesso

OTHER

3 parts matte medium to 1 part water • plastic painting knives in various sizes • spray bottle filled with water

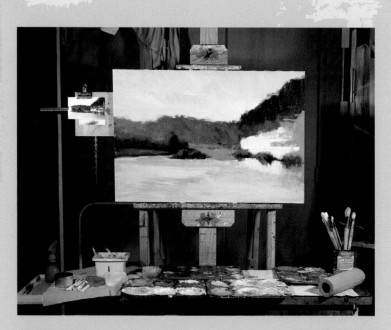

Work Area Setup

When I paint with acrylics, I set my palette of colors in the middle along with mixing trays and a container of matte medium. Plastic palette knives, brushes, a water well and a spray bottle are all within easy reach.

If you can, clip a source photo next to the easel. I also had on hand a 12" × 18" (30cm × 46cm) pastel of the same scene, which I used for color reference.

Try keeping your palette below the painting whether you're working outdoors on location or in the studio. Only when the canvas is very large do I move the palette to the side.

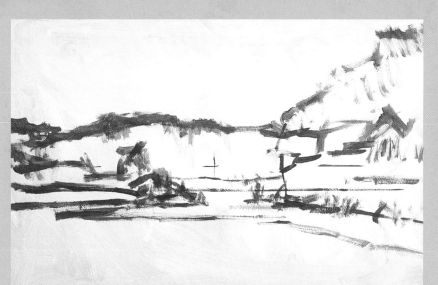

1 Prime the Canvas and Rough in the Basic Shapes

Start with a cotton canvas covered with several coats of acrylic gesso. Since I apply acrylics in thin layers, creating a brush texture in the priming layers of the gesso adds to the quality of the painting. Allow the gesso to dry thoroughly, then roughly locate the shapes with a thin mixture of warm color. You may want to locate the canvas center first to aid the effective layout of the shapes.

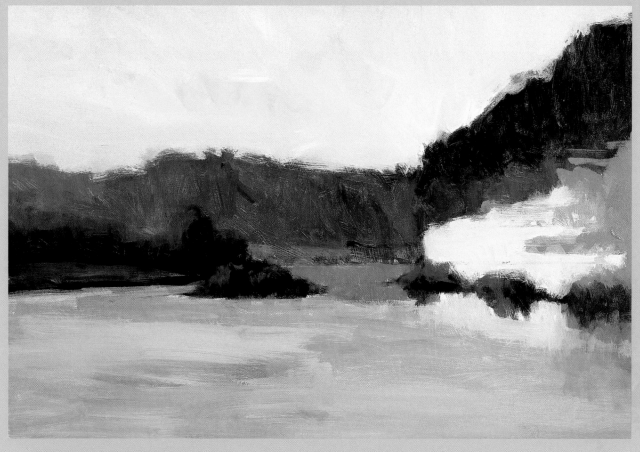

2 Establish Color and Value Relationships

Using a large bristle brush, work a lot of medium transparent colors into the main shapes. Try to keep all the color transparent at this point, and focus on establishing the value and color relationships for the painting. The exactness of the drawing is not important, so you can push and pull the edges of the masses as the painting develops. Overlap the edges of the shapes a little. White canvas showing at the edges of the shapes can be difficult to eliminate at later stages of the painting.

3 Place the Extremes
Identify the extremes within the picture and resolve them. I placed the darkest dark under the bushes at the waterline and the lightest light on the cliff face. The most intense color is on the sunlit part of the bushes, and the most dynamic edge is between the cool, dark midtone of the background and the warm lightest light of the cliff face.

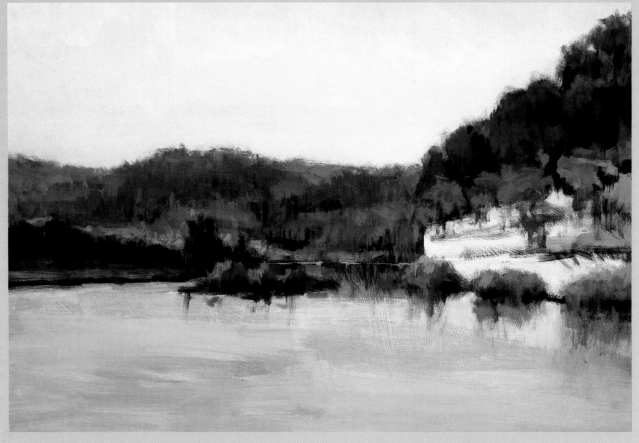

4 Work in Thin Layers
Work all over the surface in thin layers of paint. This is similar to the pastel process because the dry pigment of pastel and the fast-drying layers of acrylic have more of the color scumbled and dragged into the mass. Keep values close and color mixes analogous to build these layers and to avoid making the masses busy.

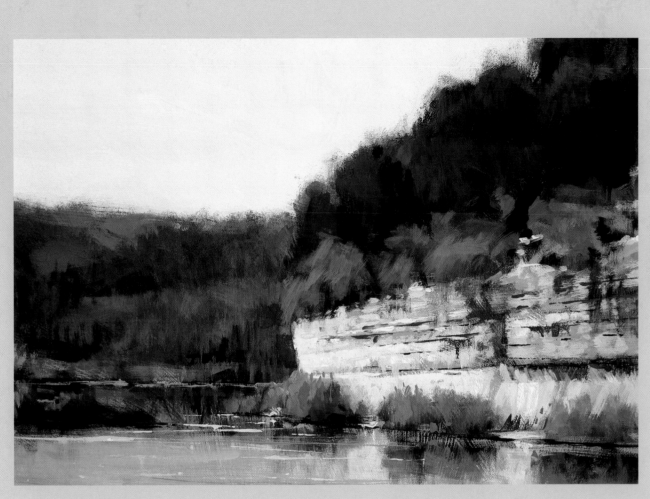

5 Apply Opaque Color
As the painting approaches completion, use the edge of a plastic palette knife to apply more opaque areas of color in the water's highlights and to the crevices of the cliff face.

The benefits of the brush texture from the gesso layer are evident in the water under the bushes where a fairly dry brush of opaque color has been dragged across the dark of the water. This is an easy and effective technique to use when you're working with a medium that dries quickly.

ACHIEVING LUMINOUS ACRYLICS

The best thing about using acrylics is that they dry fast. The worst thing about using acrylics is that they dry fast. As funny as that may sound, it's true. Acrylic dries quickly on the palette, so keep the palette sprayed with distilled water. To keep acrylic from drying too quickly on the painting surface, mix the colors transparently and create soft edges with a bristle brush. With these steps, you can achieve a luminosity similar to that of pastel.

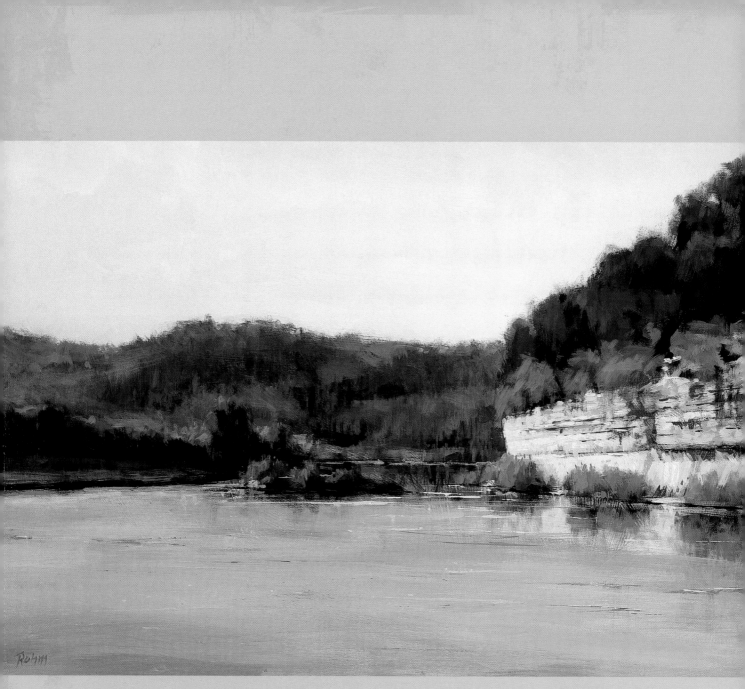

6 Carefully Apply Opaque Paint to Finish
Selectively apply opaque acrylic paint only when the painting is in its final stages. Acrylic paint by nature dries very flat and opaque. The light shades also tend to darken as they dry, so use caution when applying the final opaque colors. Remember, to be most effective, a good painting always has one element dominating another. With acrylic paintings, I prefer to have the transparent layers of color occupy more space and dominate the accents of opaque paint.

EVENING CALM
Acrylic on canvas
24" × 36" (61cm × 91cm)

WORKING WITH PLASTIC PAINTING KNIVES

When working with thin acrylics it can be hard to pick up paint with the edge of the plastic painting knife. Try mixing the acrylics with a large bristle brush and use that brush to load the paint onto the knife. Then apply the paint to the canvas using the knife.

Working with an Expanded Palette

An adjustment I've made to take advantage of acrylic's quick drying time is to add many more hues to my palette than I use with oils, and layer them on the painting with less palette mixing. This method is similar to working with pastels. Because of acrylic's quick drying time, it's very easy to rework it to adjust color, value and edges. I find this constant adjusting adds to the painterly quality of this medium, so I plan these adjustments as part of my painting process and never try to hit an edge or contour in one shot, except at the end when working with a plastic painting knife.

Materials

ACRYLIC PALETTE
Cadmium Yellow Light • Yellow Ochre • Cadmium Yellow Medium • Cadmium Orange • Burnt Sienna • Quinacridone Red Light • Quinacridone Red • Quinacridone Crimson • Ultramarine Violet • Cobalt Blue • Chromium Oxide Green • Permanent Green Light • Titanium White

BRUSHES
Six or more inexpensive hog bristle brushes from no. 2 to no. 16 • no. 6 synthetic flat • no. 2 synthetic round

SURFACE
Cotton canvas primed with several layers of acrylic gesso

OTHER
3 parts matte medium to 1 part water • plastic painting knives in various sizes • spray bottle filled with water

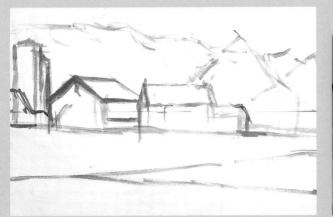

1 Locate the Masses with Correct Angles
When locating the masses of buildings, it's important to get the angles correct. Once the proper angles are set, you can cut loose and start painting. Proportions can be adjusted as the painting progresses, but you need to know the angles.

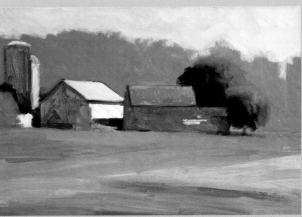

2 Paint Average Colors and Values in Thin Layers
Establish the average color and value of each main shape with thin washes of acrylic paint. Acrylic hues tend to dry flat, so keep the mixture thin and build transparent layers (similar to pastels) to create luminosity.

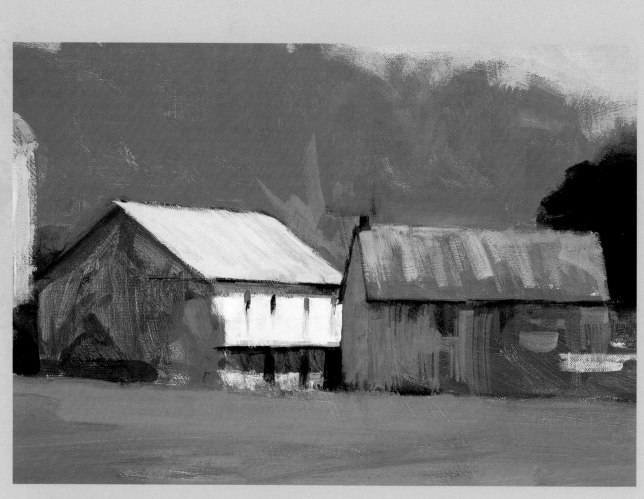

3 Establish the Extremes

Next to filling in the masses with the correct average color and value, accurately establishing the extremes of light, dark, color and edge is most important. These are your guides for painting the picture. Use them to compare all your color mixtures and brushstrokes. You can use the most beautiful and expressive painterly strokes, but they must complement and not compete with the extremes you established.

I used a strong red-orange for the sunlight on the roof and contrasted it with a transparent blue in the building's shadows. This set up a theme of complementary colors. The field is painted with a lot of orange to pick up the color from the roof. Even though this color harmony is the theme and idea of the painting, it's the contrast of the white barn against the shadow side of the house that creates the most dynamic edge and center of interest.

CONCEPTS OF THE PAINTERLY APPROACH

Regardless of the unique characteristics of your chosen medium, the concepts behind the painterly approach remain the same: work thin to thick, dark to light and transparent to opaque.

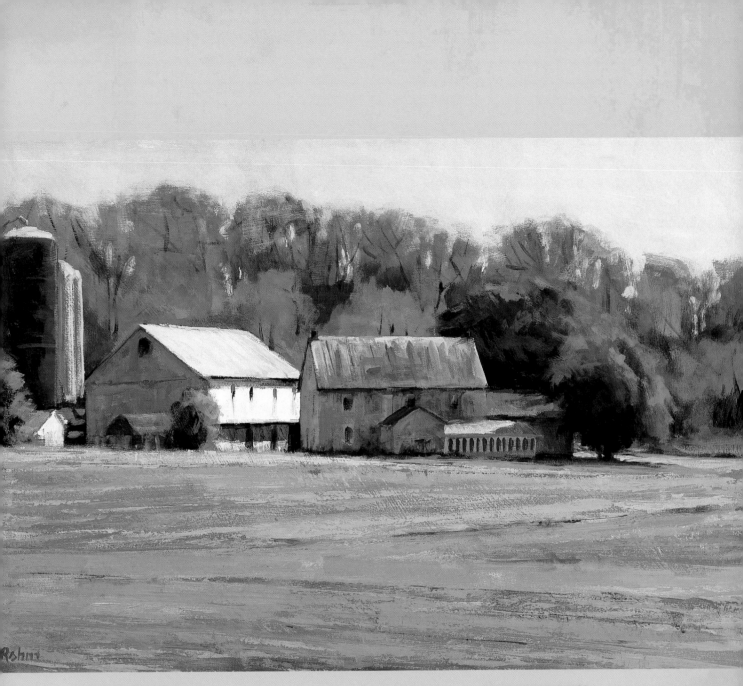

4 Add the Finishing Touches

In the finished painting I used a lot of opaque color in the field to contrast with the transparent shadow hues of the buildings. I applied these opaque colors by drawing a plastic palette knife across the surface in the direction of the furrows of the field. The broken edges of the opaque acrylic suggest the qualities of the solidness of the earth. They also contrast nicely with the thin, transparent distant trees and shadows.

The sky, although a light, opaque-looking mass, is painted in a series of layers thinned with matte medium. Painting it solid with opaque acrylic color would have made it too heavy and not allowed it the airiness it needs to work with the rest of the painting.

Notice also how nothing was added or changed to detract or compete with the extremes established early in the painting process.

PENNSYLVANIA HERITAGE
Acrylic on canvas
20" × 30" (51cm × 76cm)

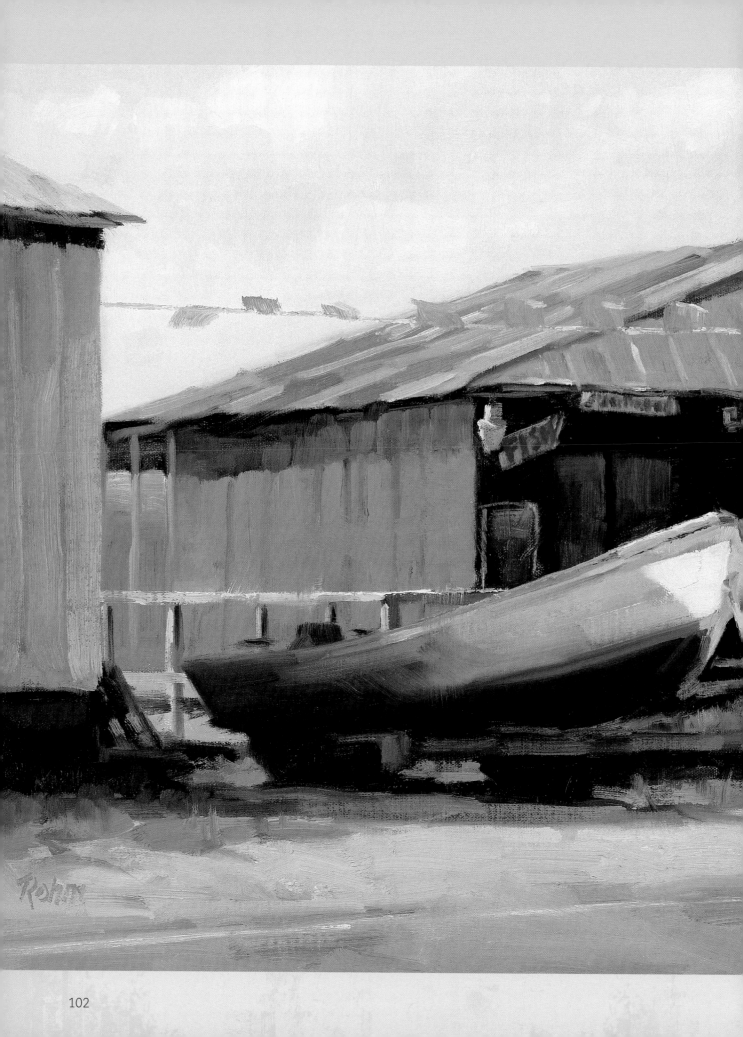

5

Beyond the Fundamentals

Beyond the basic painterly approach, there are a number of techniques you can use to resolve your idea for a picture. Some are based on close observations of natural happenings, while others are exaggerations that help you express yourself on a two-dimensional surface. Painting is a series of choices: what to see, what to include, how to represent it and how to express it.

SEAFOOD
Oil on linen panel
18" × 24" (46cm × 61cm)

Brushwork for the Painterly Approach

Paint like a sculptor. Think of how you would carve the forms in your scene if you were working three-dimensionally in clay. Then use the brush like a knife to carve the planes of the form.

Strokes not only describe the form, but also express your emotion. Don't trace the contours of an object or shape with the brush. That will flatten the three-dimensional quality of the form and not represent the relationship to other shapes.

A brushstroke should tell us about an object. Is it flat, round, horizontal, vertical, smooth or textured? Think about what you are painting and how you want to express it. For example, paint the flat plane of the ground with mostly horizontal strokes. Paint trees and bushes with a variety of angles to sculpt the form. Paint skies with vertical strokes to suggest uplift and to contrast the flat solidness of the land.

Brushstrokes can express emotion, describe form and add texture to a painting's surface. Be careful that you don't get so caught up in the excitement of painting strokes that you overdo it and make the picture busy with strokes. The beauty of a bold stroke is how well it works within the design of the overall picture. Think about what each stroke is doing in relationship to the whole and whether you need to express a shape dramatically with bold strokes or keep it quiet with soft, simple ones.

Generally speaking, shadow areas are thin, soft and mysterious, while very light areas are thick and opaque. That's not to say that a shadow area can't describe form with stokes. Just don't overdo it.

Brushwork That Describes Form
The brushwork here describes the form by sculpting it. The strokes represent the planes of the subject rather than follow its contour. Thick and thin strokes of paint add to the impression of rocks in light and shadow.

CANYON WASH
Oil on linen panel
10" × 8" (25cm × 20cm)

Establishing the Flow of the Land
Use your brushwork to describe the flow of the land. Here the trees and slanted hills are painted with vertical and diagonal stokes. The flat meadow is made with horizontal strokes, while the mountain face is carved to represent its form.

MORNING MEADOW
Oil on linen panel
11" × 14" (28cm × 36cm)

HOLDING THE BRUSH OR PASTEL FOR A PAINTERLY EFFECT

Holding a brush or pastel like a pencil puts pressure on the stroke, which is OK in the early stages when the layers are thin. However, as the picture develops and the thickness of paint or pastel increases, hold the brush like a knife and lay the new paint or pastel on the surface of earlier layers rather then digging into them.

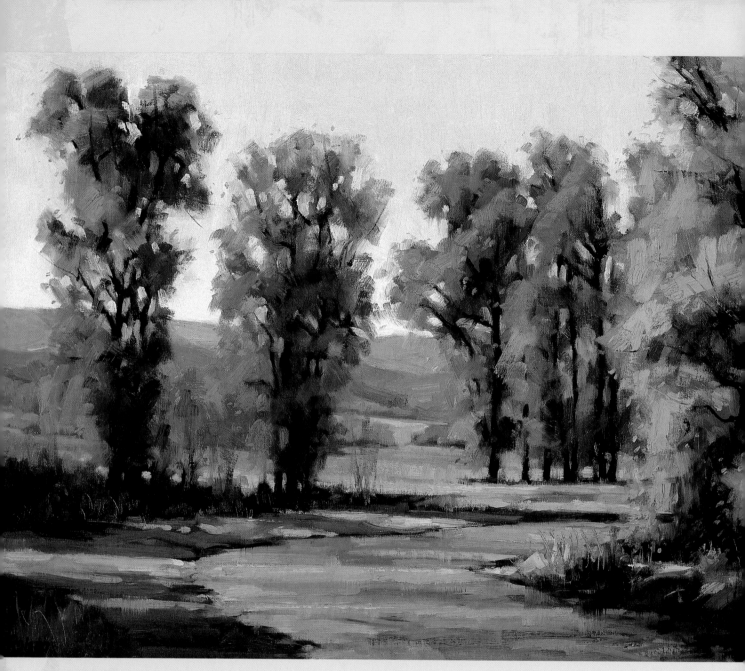

Sculpted Forms
The brushstrokes sculpt the roundness of the trees as if carving them three-dimensionally out of clay. The strokes on the ground lay flat, while the sky is executed with mostly vertical strokes.

FALL RIVER
Oil on linen panel
18" × 24" (46cm × 61cm)

PAINTING THE SKY

I generally paint the sky with vertical strokes even though the transition of color and value is horizontal from the warm gray on the horizon to the deep color overhead. The vertical strokes add uplift to the sky mass and contrast nicely with the random strokes of the trees and flat, horizontal strokes of the land. This technique is more difficult, but worth the effort.

Build the sky transition with horizontal strokes and then work back into these strokes, pulling them up vertically. Wipe the brush often because as you pull the brush up it will pick up the darker, richer color from the upper part of the sky, and you don't want to mix that into the lighter, grayer part below. This takes practice, but after a few times you will be comfortable doing it and it will feel perfectly natural.

The Painterly Sky

The principles for creating a painterly sky are not much different from those used for any large, simple mass; it's much the same as painting a large field of grasses or a body of water. There is a transition of color, your brushwork must relate to the texture of the rest of the painting, and, if the sky is a very large mass within the picture, you need to add clouds for visual interest.

As you paint clouds, notice that the undersides reflect the colors of the land, and the sunlit parts show the color of light. Clouds in sun are generally darker and duller than snow on a mountaintop. For years I was confused when I was told to paint distant clouds with more yellow than close-up clouds since you subtract yellow from objects to make them recede. (You may have heard the same statement.) I finally realized that a close-up white cloud is cleaner and brighter than one in the distance, and just adding warm color to a white cloud will make it recede. I suggest using Yellow Ochre rather than a pure yellow.

Also, dark storm clouds are never as dark as the shadows on the land, and clouds are soft-edged, even in a dramatic sky.

Materials

OIL PALETTE
Cadmium Yellow Light • Cadmium Orange • Burnt Sienna • Permanent Alizarin • Cobalt Blue • Ultramarine Deep Blue • Viridian • Titanium-Zinc White

BRUSHES
Nos. 6, 8 and 10 hog bristle flats • no. 2 hog bristle extra long filbert

SURFACE
Oil-primed linen panel

OTHER
1-inch (25mm) painting knife • mineral spirits

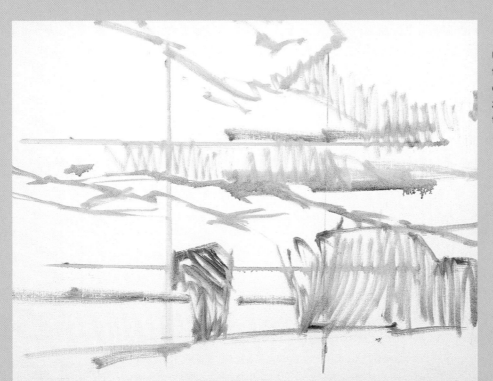

1 Divide the Canvas and Place the Main Shapes
Using a worn no. 6 flat and paint thinned with mineral spirits, divide the canvas in thirds horizontally and vertically to place the main shapes.

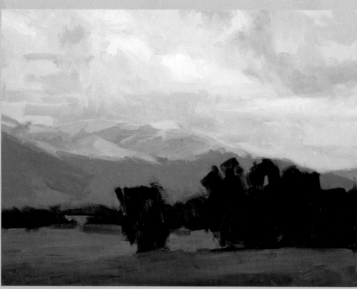

2 **Fill in the Masses**
Once you're comfortable with the size and placement of the main shapes, fill in the masses with thin mixtures of the average colors and values. When that is completed, evaluate the relationships of the entire scene and establish the extremes of color, value and edge.

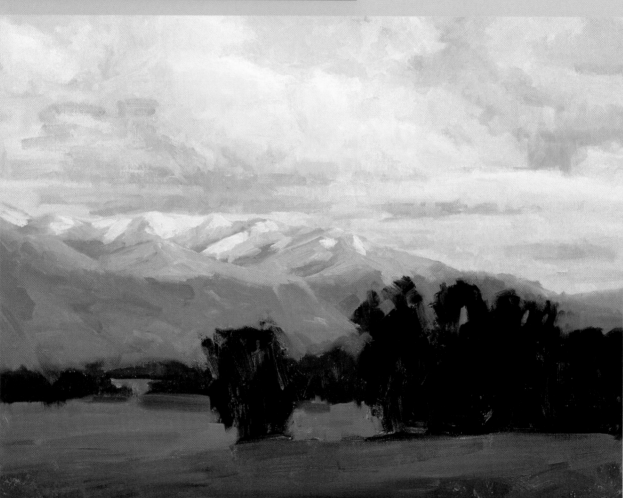

3 **Concentrate on the Major Shapes**
Using the averaged masses as a point of comparison, concentrate on the mountain, sky and clouds. Repeat the colors of the mountain's shadows and sunlight in the clouds to unify these major areas.

Clouds in sunlight are not lighter than the snow on the mountains, which are also in sunlight. This effect has to do with the solidness of the snow. Also, white is not just white; it always has a tint of color. In a scene such as this, white is dependant upon these subtle color shifts in light and shadow.

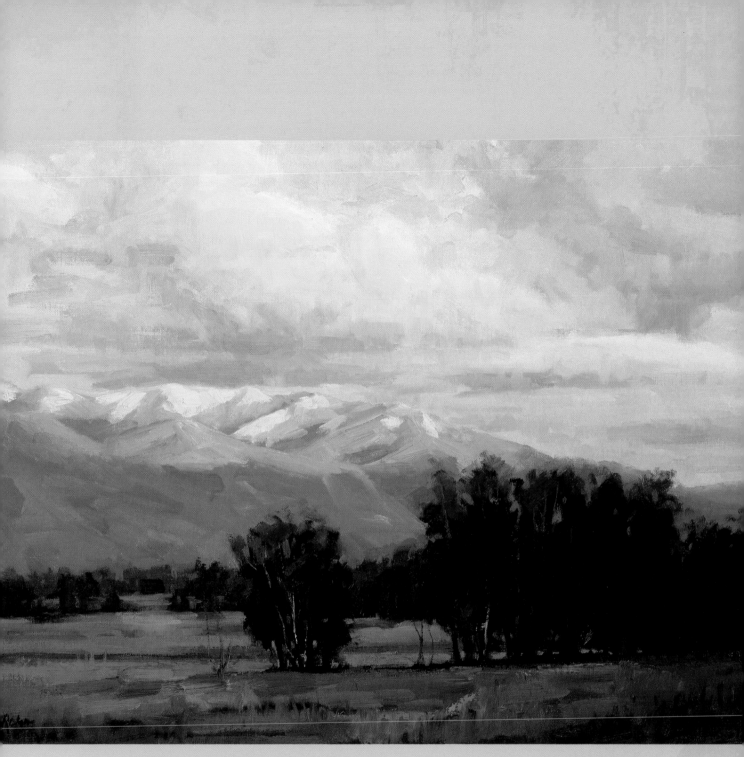

4 Finish the Painting

If the clouds were just as white as the snow on the mountains, they would flatten the space and detract from the mountain, which is where the viewer is supposed to look. Clouds do not have the dense opaqueness of snow and will not reflect light as sharply, so they will appear slightly darker in similar light.

Unify the color throughout the painting with darker yellow-greens and violets in the foreground. Notice that even the darkest shadows in the clouds are lighter than the shadows on the land.

TRANQUIL ILLUMINATION
Oil on linen panel
18" × 24" (46cm × 61cm)

Three Sources of Light

It is obvious in landscape painting to focus on the sunlight. However, for many scenes the most interesting light comes from something else. There are three sources of light to pay attention to when painting:

1. The original light source
2. Reflected light from other objects
3. The reflection of the sky

The reason for separating the two types of reflected light is that basic reflected light can be any color based on what is causing it, while the reflection of the sky is always whatever color the sky is.

The light of the sky reflects onto the top of shadowed objects and illuminates cast shadows. Cast shadows on the ground only get illumination from the sky, which is the primary reason shadows lighten as they move away from the objects casting them, allowing more sky to reflect onto them.

The shadow must contain the same color as the sky. All too often I've observed students trying to put purple shadows into a painting with a blue sky. You must maintain the color relationship between sky and shadow: A blue sky calls for a blue shadow and a purple shadow needs a purple sky.

The color of cast shadows is always a mix of the shadowed local color and the color of the sky. The more neutral the local color, the more distinct the sky color. For example, if you look at a shadow cast onto a light gray concrete sidewalk, you will see the sky color very distinctly. Reflected sky color on green grass, on the other hand, is not as obvious, but it is there.

An upright or overhanging object such as the edge of a roof takes on the colors of its surroundings in sunlight. The stronger the sunlight, the more noticeable the reflected light colors. Imagine trying to paint outdoors wearing a red shirt. Standing close to the painting, that red would reflect all over the painting and influence the color mixtures. When you step back to view the painting, the red would be gone and the color would look totally different. The same kind of reflection takes place throughout the landscape.

Look for these reflected lights to add interest to an otherwise flat, dull scene. The ground reflected up onto the underside of an overhanging roof can often be warm and saturated in color. A dark, shadowed horizontal tree limb often has a beautiful warm reflected light hitting it from the sunlit ground.

WINTER REFLECTIONS
Oil on linen panel
12" × 9"
(30cm × 23cm)

Sky Reflections
In this winter scene, the flat plane of the snow reflects the blue of the sky, while the snow on the upright pine tree catches the warm sunlight. The warm sunlight is reflected onto the shadow side of the aspen tree, which appears more intense than the sunlit snow because of the saturated shadow hue.

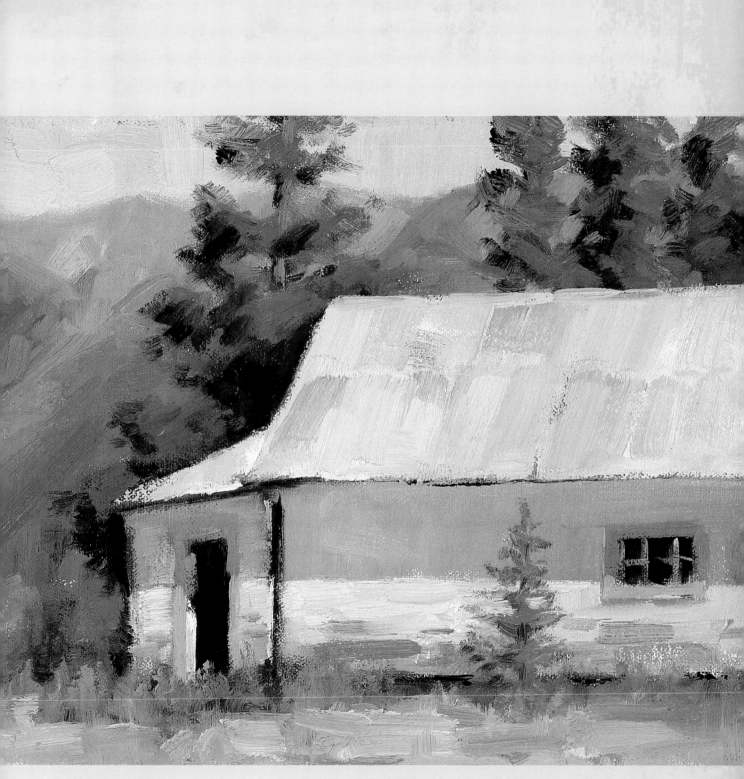

Warm Reflected Light

I was attracted to this scene because of the beautiful warm light under the roofline reflecting from the sunlit ground.

MINER'S CABIN
Oil on linen panel
8" × 10" (20cm × 25cm)

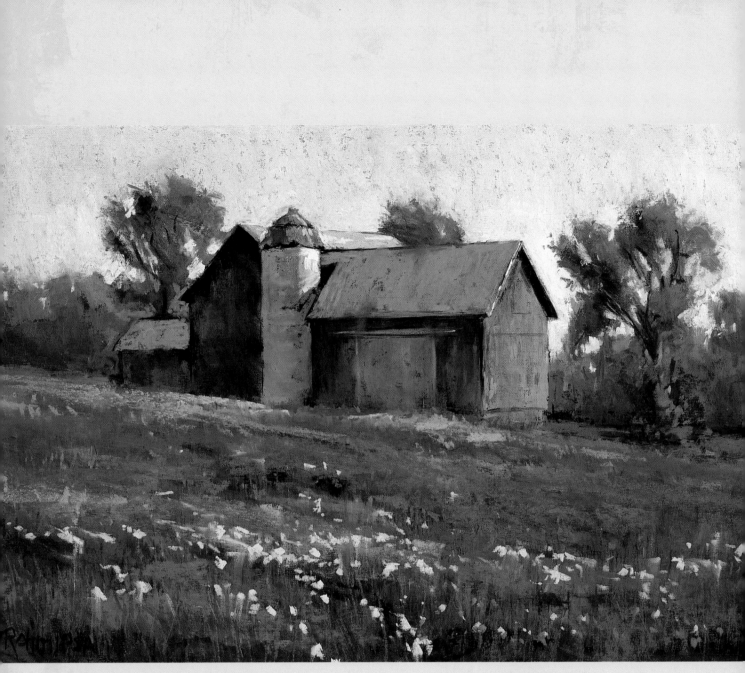

Light and Cool Contrasts

The dynamics of the warm afternoon sun are contrasted by the cool sky colors reflected onto the barn roof. The light on the silo is reflected onto the shadowed roof, and the shadow side of the silo is cooler as it moves away from the warm hue of the ground.

WILDFLOWER SUMMER
Pastel on sanded paper
12" × 16" (30cm × 41cm)

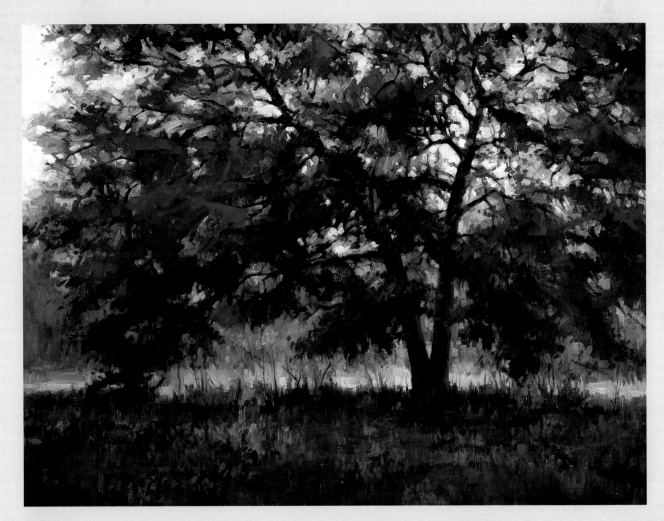

Backlighting

In this strongly backlit scene, you become aware of the warm sunlight and dark shadows. However, all three sources of light are required to make the scene dynamic. The sky is clear and its color reflects strongly onto the scene with a cool hue that contrasts nicely with the warm sunlight. The upright shadow planes are dull and neutral in hue. The dynamics of the scene, therefore, are not just the contrast of light and shadow, but also the warm light and the reflected light of the cool sky.

CONTRASTS
Oil on linen panel
30" × 40" (76cm × 102cm)

BE AWARE OF WARMS AND COOLS

For the most part, it is easy to say that the sky is the source of light and is, therefore, the lightest area of the scene. But that is not always true. Light-colored buildings, rocks, sand and snow are all exceptions, so evaluating the sky's relationship to shapes in the scene is critical. I can't even say that trees are always darker than the sky: take, for example, a yellow fall leaf against the deep blue of the sky. So, study the relationships you see and don't rely on any formulas for painting the sky.

The Color of Light

The color of the light source is something many artists overlook, as they get too involved with painting individual elements and don't think enough about the relationships between them. I've seen paintings with yellow light in one place, pink light in another and cool light in yet another, yet all were lit by the same source.

A solution some artists have for this is to determine the color of light for their painting and premix a pile of that color. As they work, they add that color to all areas falling within the light. This is a viable option, but I prefer to just be aware of the color relationships, balancing the painting as it develops with color harmony.

Viewers perceive certain color relationships as symbolic of different lighting situations. They see yellow light and purple shadows as morning light, neutral or white light as midday and orange light with blue shadows as afternoon or evening light. Though there are orange sunrises and yellow sunsets, they are not symbolic of those times of day and you need to consider that if you are trying to communicate one or the other to the viewer.

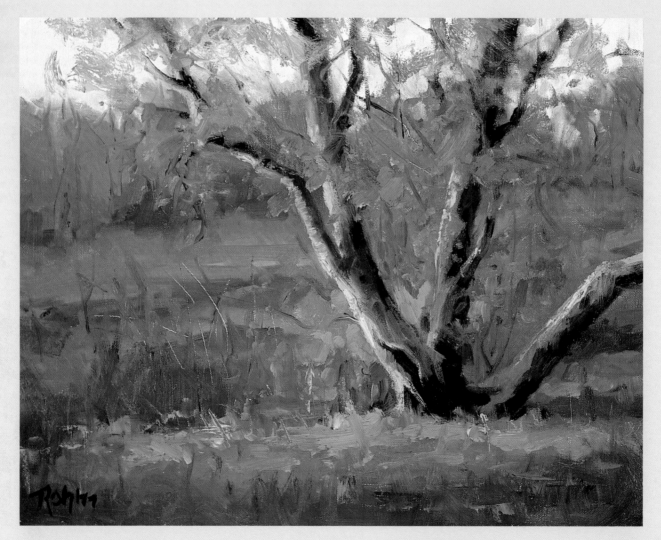

Make the Lighting Consistent
The warm pink light is represented in all sunlit areas and is contrasted by the cool hues of the shadows. In the morning or afternoon the sunlight has very noticeable color. Make it consistent throughout the painting.

CLEAR EVENING LIGHT
Oil on linen panel
11" × 14" (28cm × 36cm)

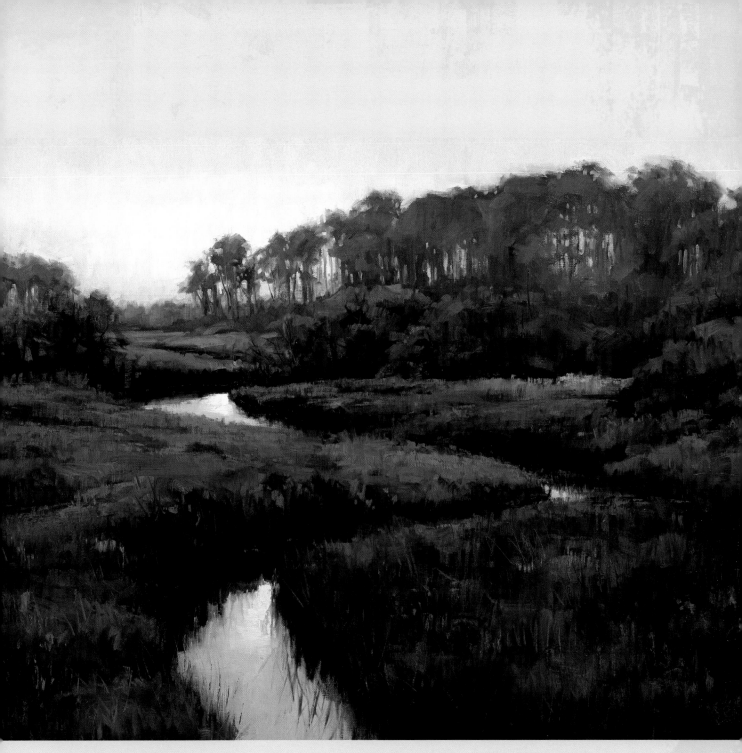

Colored Variations of Light

The warm yellow-orange light reflects into the water, and since reflections are not as high key as the source of light, the color is more saturated. As the yellow-orange light is filtered through the dark trees, the warm hue of the light mixes with the cool of the dark trees and optically mixes to become a pink glow that cools as it moves away from the source. Although they are different colors, they are variations and mixtures of the yellow-orange source.

EVENING WETLAND REFLECTION
Oil on linen panel
30" × 40" (76cm × 102cm)

Controlling the Green Landscape

"I've never seen a good green without some red in it." I don't know who first said that, but it is so very true. I first heard it when I started painting landscapes many years ago, and it is one quote that I often recall when mixing color for my paintings. It simply means don't paint green that is too intense or raw (unaltered from the tube). Many beginners fall into this trap. They find it difficult to mix greens, so they resort to buying various tubes of green hues and then use them as they come from the tube. If you are struggling with green, you are much better off removing it from your palette and forcing yourself to mix it from your other colors. I am always amazed at how dull and brown a color may look on the palette and how green it appears in relation to other hues on the painting.

When you look at the color wheel, green represents nearly one-third of the area from yellow to blue. You may encounter landscapes that are virtually all green—the grass, hills and trees—with the sky being the only part with a different color (although even the sky color is very close to the green section of the color wheel). Painting with just this one color family is very limiting. The challenge in painting such a scene is adding color to express your feelings for it.

There is no reason that a warm green area in sunlight cannot have color variations into the red to orange range, as long as it still reads as being a warm green area. Similarly, on the cool side you can push the color accents into the cool violets and still have an area read as a cool green mass. It's a mat-

ter of balance. Keep the value and color temperature consistent within the mass and you'll be amazed by how far you can stretch the colors around the color wheel and add excitement to an otherwise boring green scene. Make sure to establish the correct color for the shape and then add the variations to expand the range of hues.

There are times when painting the family of greens from warm to cool and dark to light is all that is needed to express your interpretation of a scene. The mood of such a scene is best expressed by limiting the color. However, many times seeing this limited color family does not express your feeling. Don't just stick to the green family. With more confidence, you will learn to work with these green averages to correctly relate to the scene, and also to expand the use of warm and cool color to at least two-thirds of the color wheel.

Expressive Greens
This scene stays within the local color family of green. It is expressed by controlling the intensity of the green hues from warm yellow-green to cool blue-green. Using warm and cool color relationships and values are critical to making a green scene like this work. This range of hues expresses my attitude for the scene and I didn't feel it necessary to stretch the color family too far around the color wheel.

SUMMER GREEN
Oil on linen panel
16" × 20" (41cm × 51cm)

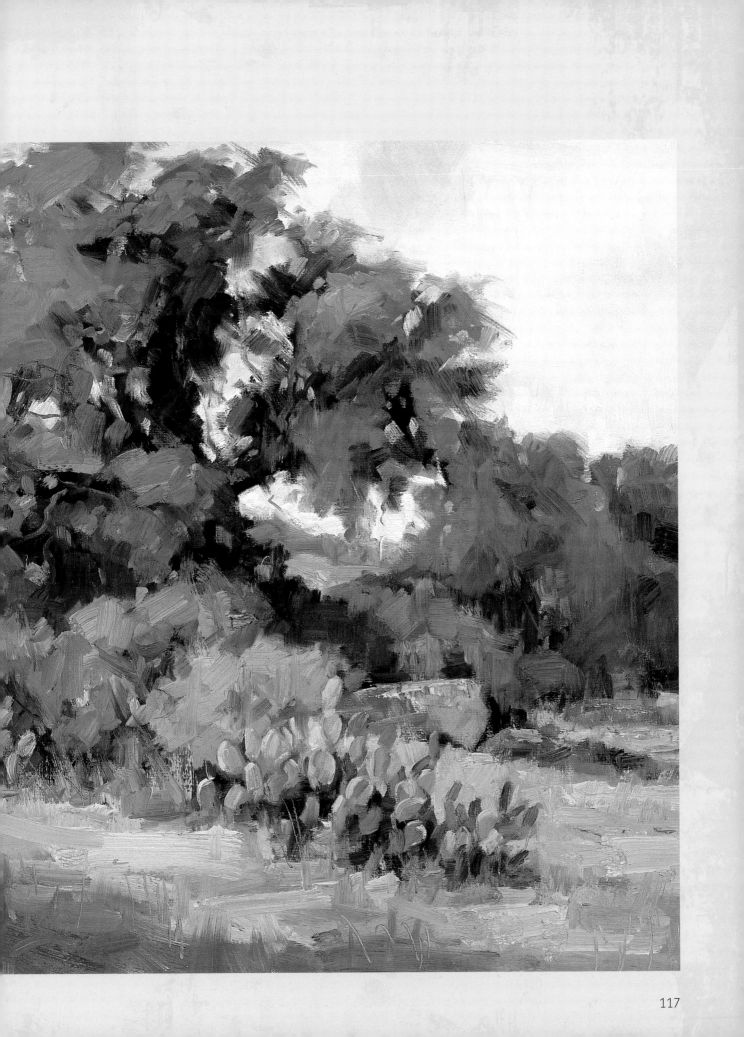

PASTEL DEMONSTRATION
Adding Vibrancy to a Green Scene

Don't ever feel limited by the local color. Use it as a starting point to expand the range of hues that express your feeling for the scene. Many times a green scene is best controlled with an underpainting of complementary colors that mixes with the greens and helps control and add variety to them. This can create a level of excitement you would never achieve by simply using the greens that you observe. There have been many times that I have used this complementary approach and decided to leave that color. Yes, you can have a red tree, as long as the value and temperature relationship to the rest of the scene are correct.

This demonstration adds color vibrancy to the green landscape by using a larger range of warm and cool colors. This approach is often used to add color variety to an otherwise boring green landscape.

Materials

PASTELS
A selection of hard pastels • A wide variety of medium and soft pastels

SURFACE
Sanded pastel paper mounted on museum board

OTHER
Mineral spirits • stiff bristle brush

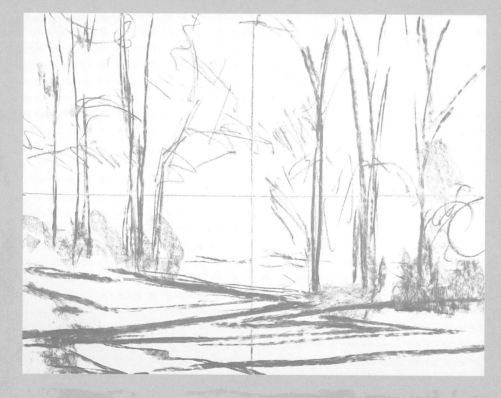

1 Begin with Warm Color and Locate the Center
Start this picture with a warm color that indicates the placement and rhythm of the vertical trees. Locating the exact center of the paper will aid in the placement of the trees.

START WITH A WARM COLOR
I use a warm color to indicate shape placements, usually a brownish red. I never use cool hues like green, blue or violet because they can create a muddy look if they show through the strokes in the finished painting.

118

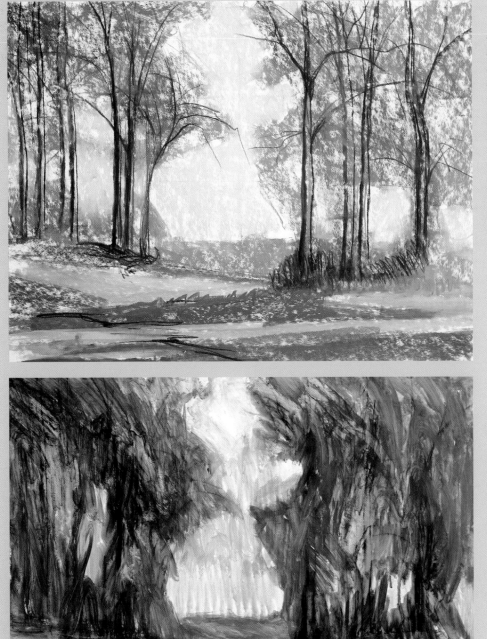

2 Apply Hard Pastels
Many times a dark object against a light one will create a transitional glow of color, so choose hard pastels that express the extreme contrast of warm and cool light. In this late afternoon scene, the green trees against the dark sky create a red-violet glow. Underpaint the trees with red-violet to emphasize this effect. Underpainting captures this glow through the layers of color and expands the color family within the scene.

3 Brush on Mineral Spirits
As mineral spirits are added to the hard pastel, they darken and blend together to form simple masses of color and value. As the mineral spirits evaporate, the color lightens to what was originally used, modified by the hue mixed with it. Keep the edges between shapes soft and don't leave hard separations or white paper showing between them.

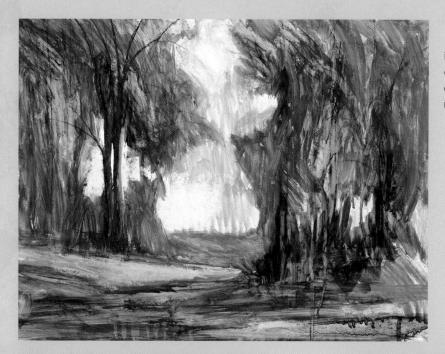

4 **Establish the Extremes**
Establish the extremes of the scene in the soft undertones. The trees are the darkest dark, the sky the lightest light and the edge between them the most dynamic. The most intense color is in the sunlit grasses.

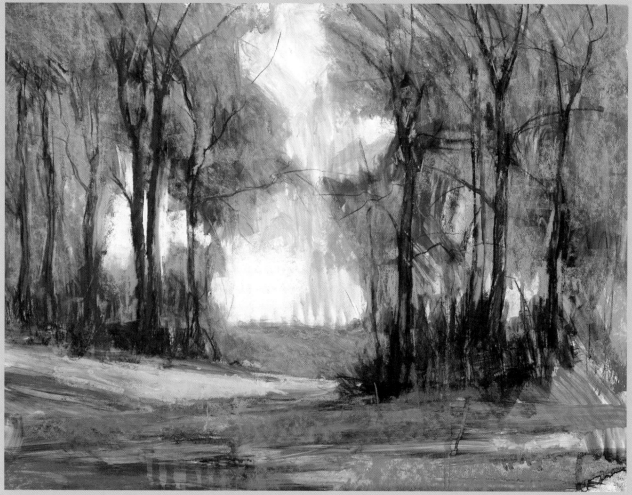

5 **Develop the Light**
With the extremes established, begin adding the blue-violet radiant light to bridge the strong light of the sky and the darks of the trees.

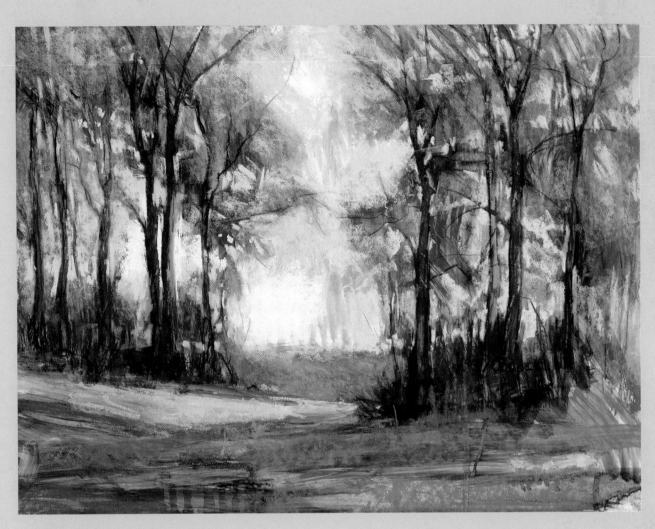

6 **Paint the Sky**
Paint the sky negatively into the violet masses of the trees.

THE HORIZON

The sky on the horizon, where it is viewed through many atmospheric particles reflecting light, is very different in appearance from the sky directly overhead, where we see fewer atmospheric particles. This causes the horizon to be lighter and to take on the color of the atmosphere. On the horizon, the sky is always warmer and grayer in color and lighter in value than the sky directly above you. The more we look toward the sun, the warmer the sky is; the more we look away from the sun, the cooler it is. So we have many factors to evaluate when painting the sky, not the least of which is how it relates to the rest of the painting.

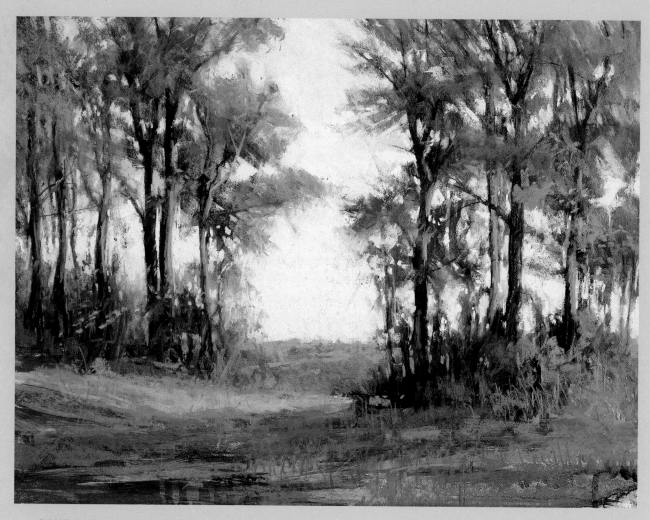

7 **Add Warm and Cool Hues, Texture and Expressive Strokes**
Add the warm and cool hues of the trees. Then add texture and color variations as well as expressive strokes of pastel.

MAINTAINING COLOR HARMONY

To maintain good harmony, add color variety and push the hues from their local color as the painting progresses.

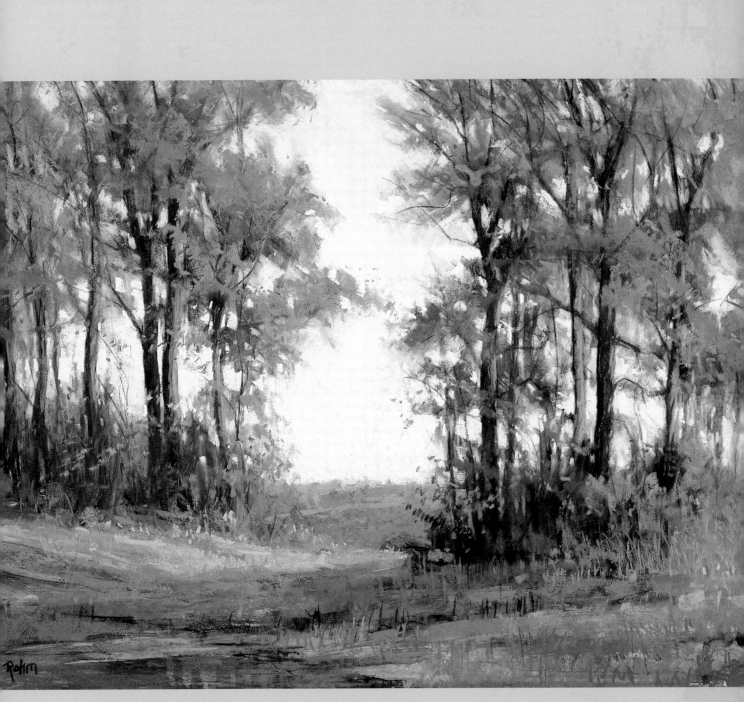

8 **Finish with Transforming Greens**
This ordinary green scene is transformed into an exciting vibration of warm and cool color. The exaggeration of color stays within the correct value and temperature relationships. Although it is still mostly green, this exaggerated color captures the excitement I felt for the dynamic afternoon sunlight.

LAKESIDE LIGHT
Pastel on sanded paper
18" × 24" (46cm × 61cm)

Creating Depth

As the land recedes in the distance, the colors appear less saturated and values and edges less distant. What you see is the light reflecting off the humidity, dust and pollution in the atmosphere. The more of these elements present, the greater the graying and haze you see.

Given enough distance even on a perfectly clear day, all color and value will eventually merge into a light gray void. I once saw this effect while hiking in the mountains above Santa Fe, New Mexico (my wife was there to witness it as well). It was a beautiful, crystal-clear day with very little humidity, and, as I looked west from my 10,000-foot (3,000m) elevated vantage point, I saw the perfect blending of the land and sky into a light mid-gray. It was a magical moment. It wasn't anything like the distance we are used to seeing in our day-to-day observations. This was theory proven.

Separate the Background

When working on a two-dimensional painting surface trying to represent a three-dimensional world with light and atmosphere, envision a veil separating the middle ground from the background. As you view the distance through this thin veil, the color is less saturated, and the value and edges are less distinct. Never take a hue from the midground to the background without altering it. Even if that separation is only a few feet, make the separation. One way to accomplish this is by mixing the hues of the upright midground areas with pure color from your palette (no white). Use the light colors instead of white. This is not always possible, but try to do this first. That way, as soon as a color moves beyond the midground and you add white to it, it's like placing it behind the veil.

This concept applies to the shallow space of still lifes and portraits as well. There is a difference of hue, value and edge between the nose and the ears. It is not extreme, but we must paint it. Remember, you are trying to represent a three-dimensional world on a two-dimensional surface with the limitations of color, value and edges.

As you look into this veil of light-reflecting particles, yellow is diminished. You can do this on your palette by mixing a yellow-green and then mixing several piles of color variations from this, each with more cool gray and less yellow. You will see an immediate recession of color.

KEYS TO CREATING DEPTH

As you work toward the background, remember:

- Darks get lighter.
- Lights get darker.
- Edges get softer.
- Color gets duller and grayer.
- Everything is trying to become a light-middle value of gray.

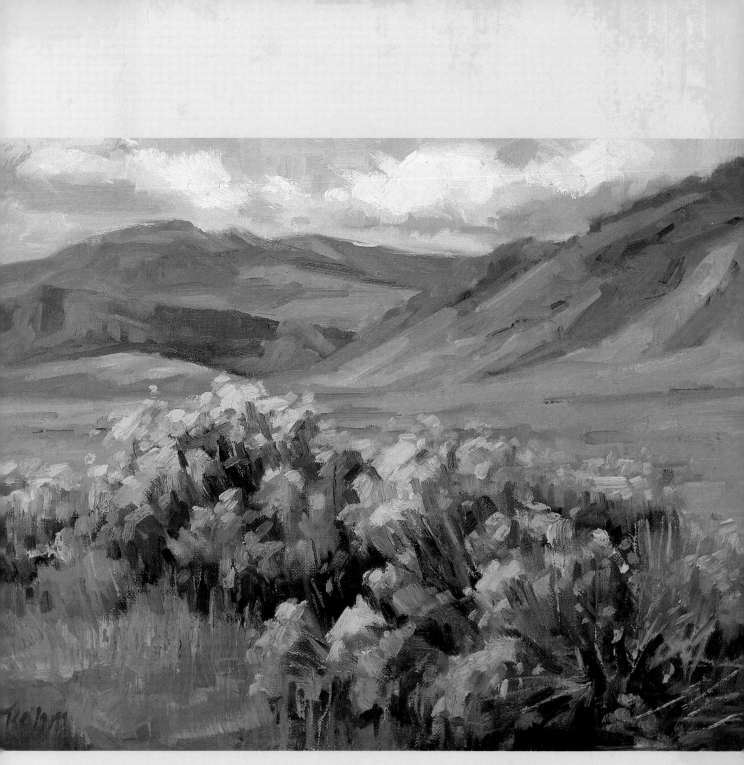

Diminish the Use of Yellow
This is an exaggeration of the loss of yellow as color recedes, but it does dramatize the effect. All color in the distance is cooler and grayer as it is seen through layers of haze.

RABBIT BUSH
Oil on linen panel
12" × 16" (30cm × 41cm)

PAINTERLY CLOUDS

Clouds are always questionable. Do you need them? What will they add? What kind should you include? They can be anything from soft-edged wisps to large, heavy masses. They can break up the mass of the sky, or be the center of interest. Clouds are also a great opportunity to move color from the land into the sky.

Suggesting Depth and Atmosphere

In the following demonstration, the strongest contrasts, the lightest light and the center of interest are in the distance. By using less intense color and adding white to the paint mixtures, the mountains and clouds will appear very distant from the middle-ground trees. All of the middle-ground upright trees are saturated color without any white paint. Every color in the distance of this painting, however, will have white added to it, creating a sense of distance as viewed through layers of atmosphere.

Materials

OIL PALETTE
Cadmium Yellow Light • Permanent Alizarin Crimson • Ultramarine Blue • Mixture of Titanium-Zinc White • Chromatic Black • Monochrome Warm • Monochrome Cool

BRUSHES
Nos. 6, 8 and 10 hog bristle flats • no. 2 hog bristle extra long filbert

SURFACE
Oil-primed linen on panel

OTHER
1-inch (25mm) painting knife • mineral spirits

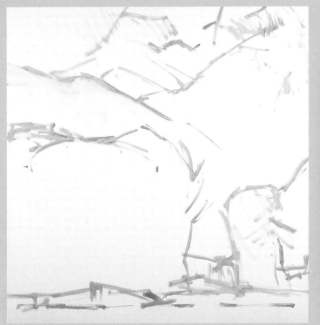

1 Locate the Major Masses
Using warm color thinned with mineral spirits, generally locate the main masses.

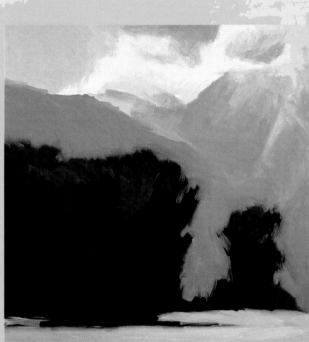

2 Establish the Average Relationships and the Extremes
With the line wash as a guide, establish the average color and value relationships, and then the extremes of value, color and edges.

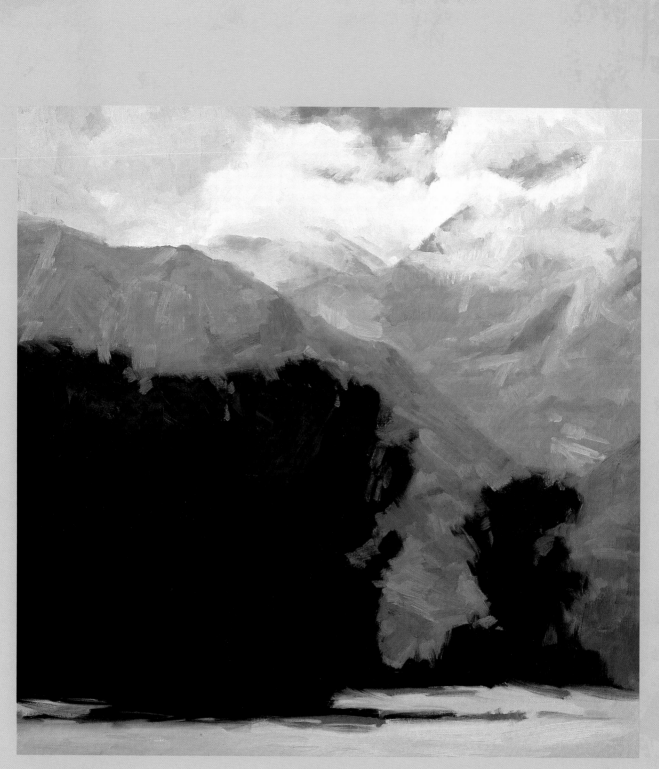

3 **Create Distance**
At this stage, the distant clouds and mountains are, for the most part, finished. Had the color and the dark value not been established in the underpainting, you would not understand how cool, gray and soft the color of the distance should be. Notice how similar the values are within the distant mountains. Contrasts of color and value increase in objects closer to the viewer because they are viewed through less atmosphere.

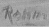

4 **Complete the Painting**

As you finish the painting, do not add white to the upright trees in the foreground to emphasize the space between them and the mountains. Repeat the sky colors into the snow at the bottom front of the picture. The cool grayness of the mountains contrasts with the saturated warm colors of the trees to create a strong sense of depth.

CLEARING SNOWSTORM
Oil on linen panel
30" × 30" (76cm × 76cm)

People and Animals

People and animals make for interesting, painterly subjects. In addition to all of the mood, color and lighting features of a landscape painting, the actions of the subject present a range of new poetic and expressive possibilities.

Ask yourself, "Will the painting be about the people or animals, or are they merely an element of the scene? Are they featured in a particular environment, or is the place unimportant to their action?" Once you make this determination, you'll have a solid idea of how to evaluate their shapes in the composition.

Scale the figures and animals correctly. They should look like they could go into a door or behind a fence. If you make the figure too small, the trees will seem gigantic.

Proportions are also very important. Many artists have a tendency to paint heads too large, which makes the figures look childlike. Think about the relationships.

As with a featured tree or rock, a group of people or animals should connect and merge so that only the edges that define the mass or action are important. Like buildings or trees in the landscape, they need to connect to the earth, so don't put any hard edges between their feet and the earth. Use defining edges only where they separate from the background or sky.

If a figure or animal is just a piece within a large scene, you should be concerned only with its shape, not its features. You don't need to see the eyes and nose of a small distant figure to know what it is. It is more exciting to suggest it than to tell the whole, detailed story. Practice painting the idea of a figure or animal with simple shapes.

I cannot emphasize enough the importance of painting a person or animal in the same manner as the rest of the scene; think of them abstractly as shapes of color, value and edges. If you think about them or their parts for what they are, you will lose their balance as an element within the picture. To make sure that a figure feels like part of the work and not pasted on top, handle it in the same way as the rest of the painting, using the same amount of drawing, gesture and edge control.

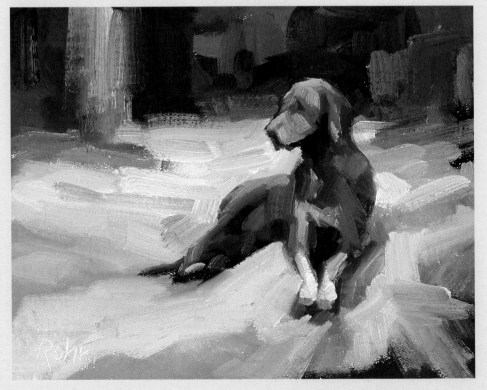

Simple, Abstract Background
As with a figure study, use the suggestion of surrounding value and color to enhance the subject and not distract from it. A good abstract design is always more important than detail.

DOG DAYS
Oil on linen panel
6" × 8" (15cm × 20cm)

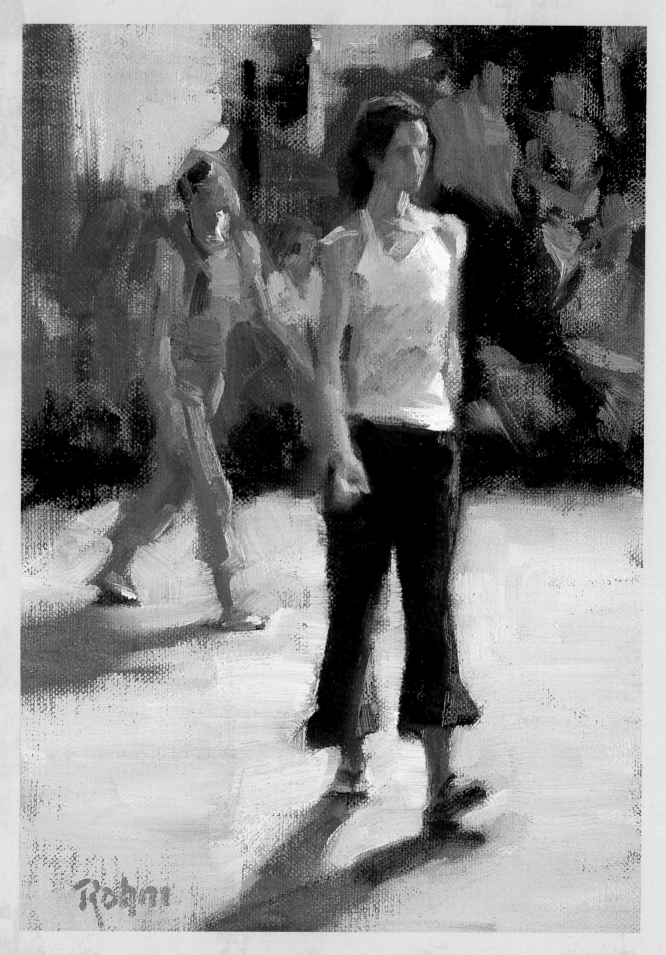

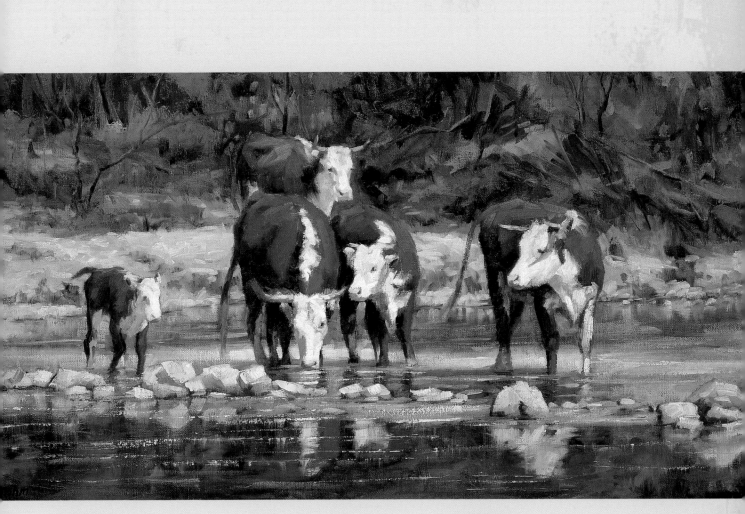

Control the Focus

As with the figure and landscape, keep the background poetic and suggestive so that the main focus will be where you want it. All cows are not created equal, and the edges, color and direction are used to focus attention on the main one drinking.

THE CROSSING
Oil on linen panel
15" × 30" (38cm × 76cm)

Focus on the Main Figure and Use Soft Edges

As with a landscape, accent the main figure and allow the others to suggest action and support the primary interest. Make sure to connect the figures to the ground by using soft edges. Otherwise the feet may appear too heavy, and the figure will float above the ground.

BELL BOTTOMS
Oil on linen panel
10" × 7" (25cm × 18cm)

Painterly Trees

The old saying goes "If you want to know how many leaves to paint on the tree, look at the sky." In other words, a tree is not described by its leaves, but rather by its contour and form. Again, shape, value and color are far more important than detail in expressing a subject such as a tree, bush, rock, animal or person.

Trees either have a dominant mass such as the solid trunk and heavy branches of a summer oak or the light airiness of a bare-branched winter tree. The summer tree is painted as a large mass of average color and value into which you add the sky holes, while you paint the mass of the sky for the winter tree and add the suggestion of the branches into it. Always squint at the subject and paint the dominant mass.

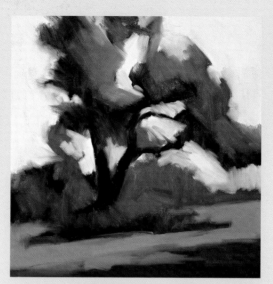

The Painterly Tree
Squint to find the average of the large masses. Ignore the small sky holes; they will be added to the mass of the tree as the painting develops.

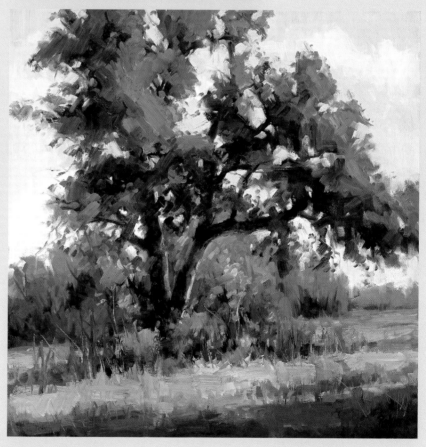

Focus on the Mass
Paint the mass of the leaves as a form the same way you would approach a cloud, rock or bush. The tree trunk has a variety of strokes to express its length and roundness. Warm reflected light from the sunlit grasses reflects onto the overhanging branches.

TEXAS SLOPE
Oil on linen panel
20" × 20" (51cm × 51cm)

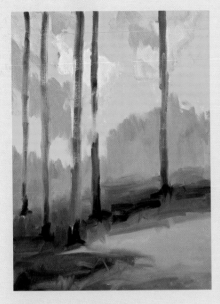

Aspen Trees Underpainting

In a scene such as this, with many thin verticals, it is very important to be aware of the negative spaces between the trees. Place them in such a way as to create a rhythm of spacing, and be careful not to duplicate the size of tree trunks and negative spaces.

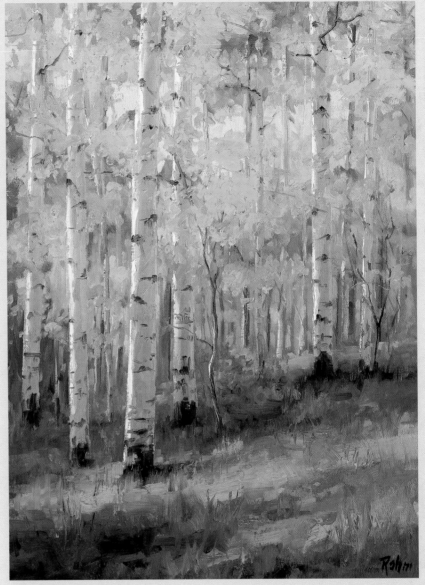

Suggest the Tree's Form

The fun of painting a light, neutral object such as the trunk of an aspen or birch tree is seeing all the reflected colors. As the tree grows upward, it reflects the color of the sky, while the lower part catches the reflected colors of surrounding trunks and leaves in sunlight. The fall is particularly dramatic with all the reflected colors.

Don't just trace the vertical contour of the tree; pull some stokes across the trunk to suggest the roundness of its form. It's not flat, so don't paint it that way. And remember to soften some of the vertical lines of the tree trunks, or they will appear too ridged. This is true also for subjects like fence poles and utility poles.

YELLOW TREES
Oil on linen panel
24" × 18" (61cm × 46cm)

Painting Water

Water is a fascinating painting subject. It can be the feature of the painting, a device for bringing the sky colors into the lower part of the picture, a dynamic design shape within the structure of your work, or any combination of the three. You could devote your career to painting the variations of it as a subject.

For the everyday artist, water is just another element of the landscape that shows up in scenes from time to time, like rocks and trees, so you handle it like any other object. Study its relationship to the other masses of the scene. It is just another shape of color, value and texture. The more you paint water, the more you will understand how to handle it.

Water is different from other landscape elements, though, because it is sometimes reflective, sometimes transparent, sometimes running or crashing in waves. Here are some properties of water to help you understand what you see:

- You either look through water to what is beneath it, or you see the density of clouded water, reflections on the surface, or white, churning water. Always start by asking yourself which of these you see.
- On an overcast, gray day, look for a subject with strong value contrast to create dynamic shapes. When painting a wave, watch for the transparent quality as the water thins close to the top of the wave compared to the density of its base.
- Reflections in water are never as sharp and clean as the object being reflected, even in what

appears to be a perfect mirror reflection. Darks are always lighter, lights are darker, colors duller and edges softer; the reflections of the white water are not as light as the white water itself. The reflection is directly below the object creating it. The slower and calmer the wind, the more pronounced the reflections will be.
- Water reflects what's around it, so don't introduce a new color not found in the rest of the scene.
- When the wind breaks the surface or the water encounters an object like a rock or log, the ripple reflects a glare of light. This often happens along the edge of a lake where you will see both a very dark line and the light glare.
- A small wave or ripple is partially reflective, showing the sky and land in the distance ahead of you. It is also partially nonreflective, allowing you to see into the water. This is where you see the color of the water or the objects beneath it. For example, you may see the rock that water is washing over or the mud on the bottom of the stream bed. In another part of the ripple you may see the sun or light glaring on the water's surface. And in water crashing at the bottom of rocks or in a wave, you can see the broken splashes reflecting light.

With these concepts in mind, look again and ask yourself what you see and why. Even a muddy river can be beautiful from the correct angle when you see the sky and landscape reflected onto its surface. Are there rocks causing the water to move and

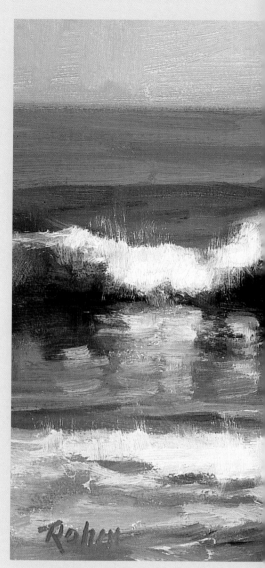

change direction, or is it calm and transparent or reflective?

The brushwork for water is pretty straightforward. Paint reflections with vertical strokes, and the flat surface of the water with horizontal strokes. Paint cascading water like a sculptor, carving the form three-dimensionally with a brush. You need fewer edges than you probably think you do. I often use the edge of a painting knife to create a horizontal highlight on the soft, smooth surface of a body of water.

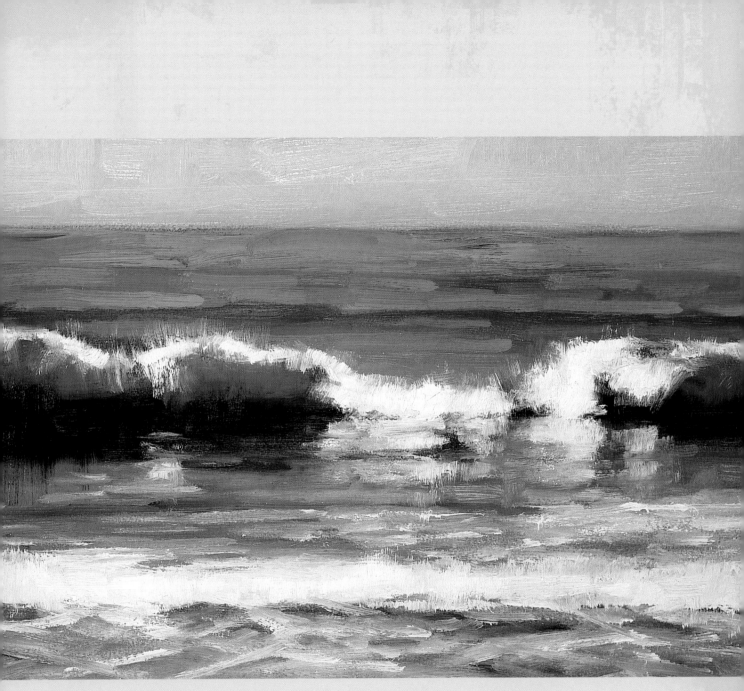

Study Movement and Color

Stand and watch a wave as it rolls onto the shore. Notice that every few moments a similar wave will occur with a height, color, white water and pattern similar to the first one. Even with small waves in a bay or lake, you will see this repetition, which gives you the opportunity to study the waves' form, value and color. The painting above illustrates this idea. Notice how the use of strong contrast and edges are vitally important to giving this simple scene a center of interest and good design.

Keep the darker parts of the water thin and transparent, and make the more active areas in the lights thick and opaque, just as you would do for the lights and shadows in a typical landscape of trees and grass.

THE BLUE WAVE
Oil on linen panel
8" × 16" (20cm × 41cm)

Reflections in Water

One of the joys of working in pastels is the flexibility they allow in combining various mediums. In the following demonstration I used pencil and a watercolor underpainting. I established a base of local color and correct value to show through subsequent layers. This is similar to using solvent to dissolve hard pastels, or painting a thin underpainting of oil or acrylic. The finished appearance is a little different, but the concept is the same. I encourage you to experiment.

The watercolor underpainting was chosen for how the fluid color would look showing through the waves. Other mediums would create a more solid look. This is a minor point, but it is my reason for choosing this approach.

Materials

PASTELS
A wide variety of medium and soft pastels

WATERCOLOR PALETTE
Cadmium Red Light • Cadmium Orange Deep • Aureolin Modern • Manganese Violet • Ultramarine Blue • May Green • Cobalt Turquoise • Prussian Green • Hooker's Green • English Venetian Red • Van Dyke Brown • Payne's Gray Bluish

BRUSHES
Inexpensive no. 10 hog bristle filbert

SURFACE
Sanded pastel paper mounted on museum board

OTHER
HB lead pencil • spray fixative

1 Start with a Drawing
Start this painting with a lead pencil so you can use strong darks in the first layer. Spray it with fixative to strengthen the darks and minimize the layer of watercolor mixing with the pencil.

2 Develop the Masses
Develop the masses with watercolor washes on the sanded pastel paper. The rich color and transparent character of watercolor will aid in creating the mood of the subject.

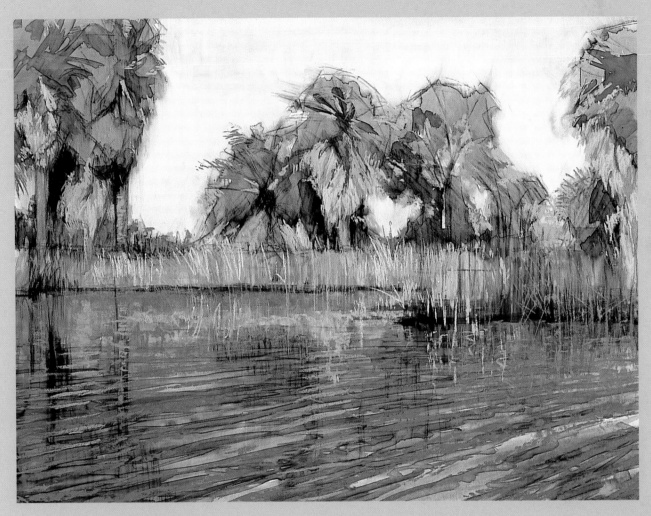

3 **Capture the Reflected Colors**
Begin laying on the pastel to capture the colors reflected in the water. Do not be concerned with the edges at this point, but rather with capturing the effect of different colors reflecting on various places in the rippled water.

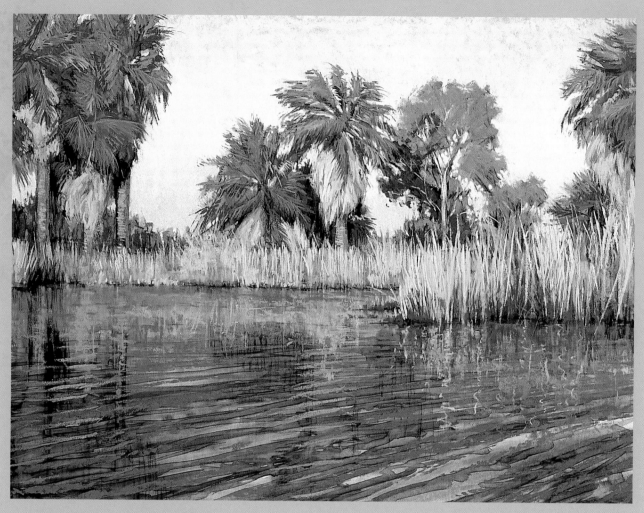

4 **Develop the Trees, Grasses and Sky**
As you become comfortable with the ripples of the water, start to work around the painting slowly, developing the trees, grasses and sky, always with an eye to reflecting those elements. Work back and forth between the object and its reflection. If they are painted as separate elements you risk them not relating to one another.

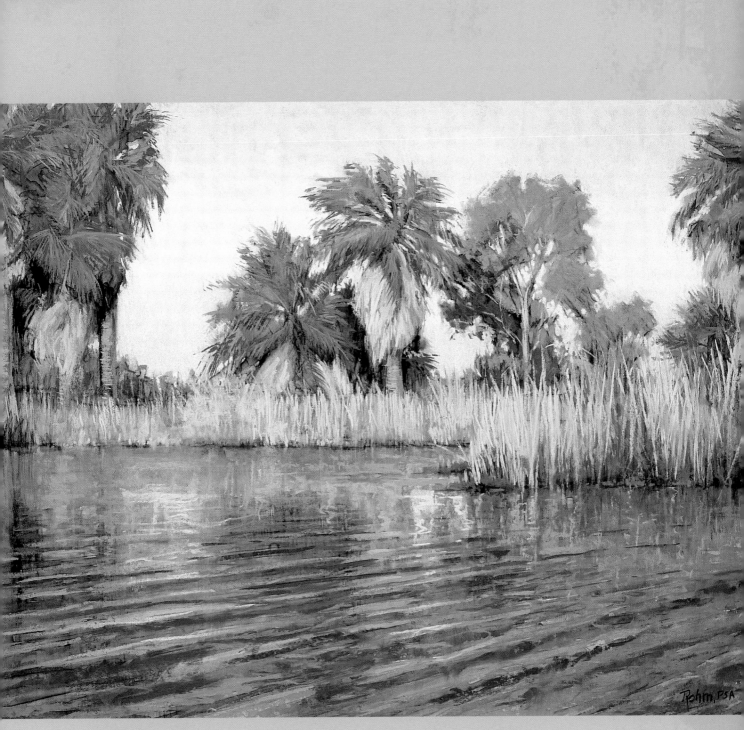

5 Complete the Painting

When you observe rippling water, the waves closer to you are more visible, allowing you to see all the parts of the wave. When looking at distant waves, you'll only see the part of them that reflects what is behind them. These waves should be simplified into more solid reflections. It's important to bring the reflection directly below the source with edges that are softer than those of the source. Remember that the darks will be lighter and lights darker and the reflections in water will never have the same clarity as their source. In this case, the darker color in the water is more saturated than the grasses and trees in the bright desert sun.

OASIS
Pastel on sanded pastel paper
18" × 24" (46cm × 61cm)

The Painterly Checklist

It is helpful to make a checklist and post it in your studio or put it on a card that you can carry on location. Whenever you are stuck or are not sure if what you are doing is working, refer to the checklist and do a self-critique for each item. Also, review each point in a finished work before you frame it.

Concept/Idea. What idea or mood do you want to convey? What strikes your interest? What do you want the viewer to feel about your experience of painting the scene?

Shapes. Simplify the scene to the fewest number of shapes possible. Six to eight is ideal. These shapes are determined by their average color and value. Look for opportunities to link darks, midtones or lights together to simplify the number of shapes.

Most dynamic edge. Identify the center of interest. Sometimes the subject determines this for you. Most times, particularly in landscape painting, this is controlled by how you organize the shapes on the surface. It is often what attracted you to the scene to begin with. No matter how similar the length of a tree line against the sky or a line along a river's edge may appear, make one place more dynamic than the rest.

Extremes. These are the most dynamic elements in the painting. Even when you see similar areas, make one dominant in terms of color, value and edge. For example, there is nothing wrong with using a lot of intense color in a painting as long as one of the colors clearly dominates the others.

Value key. Make sure the painting fits one of these value keys: low, middle or high. Add accents that cover the entire value scale from black to white, but the overall picture should be dominated by one of the three value keys.

Color harmony. I don't worry about color harmony until I get into trouble and the color is not working. Then I figure out which harmony (analogous, complementary or triadic) most closely fits the picture, and then adjust the colors to fall into that harmony. Nature has a way of harmonizing color by itself. It is man's influence that usually messes it up.

Color temperature. In painting there is always a dominant and subordinate characteristic to each element. Determine if the painting is mostly warm hues or cool ones. It cannot be equally balanced.

Color of light. Is it morning, afternoon or evening? Don't let the local color of the subject influence the color of the light—it should remain consistent throughout. Too often this is overlooked, and we find pink light in one place, yellow in another, and so on. Unify the color of light.

Color of cast shadows. Cast shadows (as opposed to the upright shadows on an object) get their illumination solely from the sky. Therefore, they must contain the color of the sky directly overhead. Don't show a violet shadow with a blue sky. They must be consistent. Like the color of light, the color of shadow must be a unified temperature and hue as affected by the local color.

Painting gesture/Texture. Make sure to unify the painting strokes and texture. You don't want to have a smooth, flat sky in a work full of bold and lively strokes of color. It must be consistent, so if you use broken color to show a field, you must then use broken color in the sky as well. In that way, the entire painting feels like it was done by the same artist. Some areas can and should be more gestured and suggestive in a painterly manner, but the surface and scene should hold together as a complete unit.

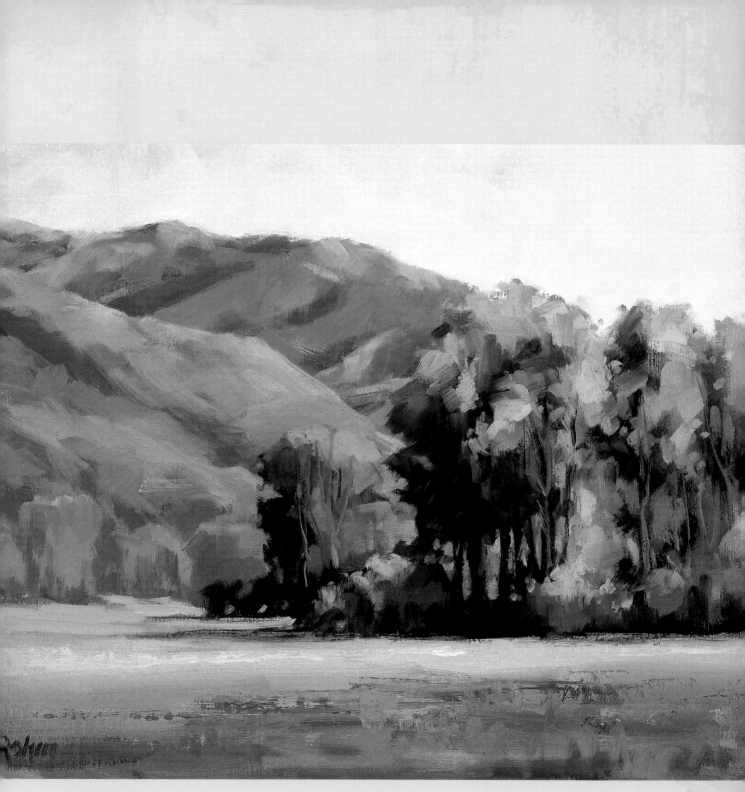

AFTERNOON COLOR
Oil on linen panel
11" × 14" (28cm × 36cm)

index

The best in art instruction comes from
North Light Books!

Landscape Painting Inside & Out
Master the art of observation, and translate field notes and sketches into fully realized studio paintings.

ISBN-13: 978-1-58180-755-4
ISBN-10: 1-58180-755-4
Hardcover; 144 pages; #33422

Mastering Color
Learn how to maximize color and its properties as you go beyond the color wheel for an understanding of the emotional and practical uses of your color palette.

ISBN-13: 978-1-58180-635-9
ISBN-10: 1-58180-635-3
Hardcover; 144 pages; #33214

Mastering Composition
Follow the principles in this book to eliminate repainting, overworking and frustration by creating harmonious, unified, powerful paintings.

ISBN-13: 978-1-58180-924-4
ISBN-10: 1-58180-924-7
Hardcover; 144 pages; #Z0561

These books and other fine North Light titles are available at your local fine art retailer, bookstore or online suppliers. Also visit our website at www.artistsnetwork.com